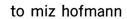

to miz hofmann

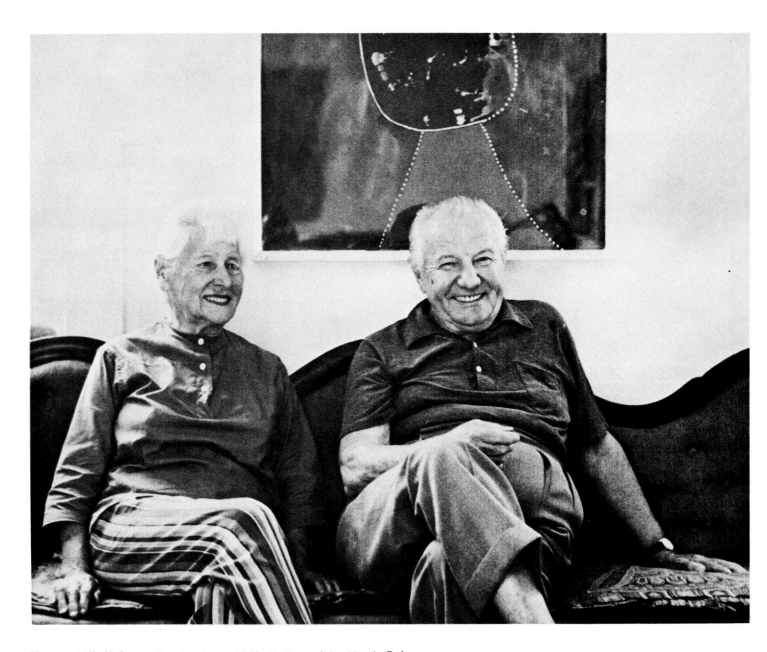

Hans and Miz Hofmann, Provincetown, 1962. Photograph by Marvin P. Lazarus.

hans hofmann

by william c. seitz
with selected writings
by the artist

the museum of modern art,
new york

Reprint Edition 1972 *Published for The Museum of Modern Art by Arno Press*

acknowledgments

The exhibition which this book accompanies consists of forty major works. Following the New York showing it will travel in the United States, South America and Europe, under the auspices of the International Council of The Museum of Modern Art. On behalf of the Trustees, I wish to thank the collectors and museums who have graciously lent paintings. In addition to lending, Mr. Hofmann and Samuel Kootz, his dealer for many years, gave essential help in selecting works and securing loans.

I am also grateful to those who contributed to the book: Mr. Hofmann, for selecting from his writings and criticizing my presentation of them; Alice Hodges and Fritz Bultman, for biographical data and advice; Alicia Legg, for preparing the chronology and the catalogue; Inga Forslund, for the bibliography; Helen M. Franc, for reading the manuscript; Susan Draper, for the book design; Harry Abrams, Inc., Mr. Hofmann and Mr. Kootz, for special assistance.

Finally, I must record my gratitude to Miz Hofmann, with whom, for as long as it was possible, I discussed every selection. Her eye was as sharp as her spirit was luminous.

© 1963, The Museum of Modern Art
11 West 53 Street, New York 19, N. Y.
Library of Congress Catalog Card Number 79-169314
ISBN 0-405-01572-0
Printed in the United States of America

contents

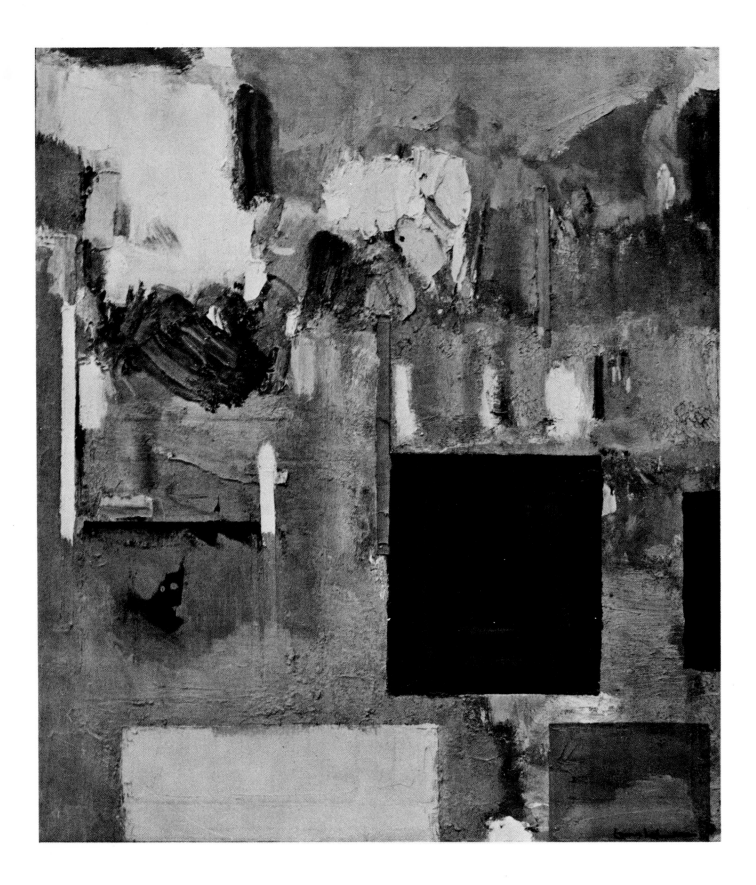

Hans Hofmann, now working at a peak of production few younger painters could sustain, is one of our major masters. He is a symbol of both the international origins of American painting and its subsequent world influence. It is a sign of greatness, in the career of an artist, when his personal development cannot be separated from that of his epoch: such is the case with Hofmann. He is both a synthesist, who in his work and theory has concentrated the tradition of which he is a part, and a radical innovator who has given impetus to three generations of artists.

Hofmann has played an active part in the modern movement, in both Europe and America, during many of its most crucial phases. By 1898, when he was eighteen, he had been introduced to impressionism in Munich. He was in Paris by 1903, where he frequented the circles in which the forms and principles of twentieth-century style were being initiated. A bit older than Picasso and Braque, he knew them both, and sketched beside Matisse at the Grande Chaumière. Robert Delaunay, whose palette did not take on the hues of the spectrum until several years after Hofmann met him, was a close friend: "It was I," Hofmann says, "who made Delaunay aware of Seurat." By having the good fortune to begin his career at the place and moment of the modern movement's inception, Hofmann learned at first hand the lessons of impressionism and neoimpressionism, and lived through fauvism and cubism as a participant. Later, forced by the war to return to Munich, it was Hofmann who preserved many of Kandinsky's important early works from destruction. Among other contemporaries whom he especially admires are Mondrian, Arp, and Miró.

These references give some indication of the fertile soil out of which Hofmann's art grew. In part, perhaps, because he has crossed more significant barriers, national and aesthetic, than almost any other twentieth-century painter, he has never been a follower; nor was he ever an expressionist, a fauvist, a cubist, or a surrealist. From childhood, when his lifelong interest in nature, music, poetry, and science began, he possessed a keen sense of his own direction and identity, an inborn self-confidence and optimism, and an unsentimental passion for reality. Whether judged by his life, his painting, his ideas, or his teaching, the structure Hofmann has erected stands bold and uncompromising, like a severe and unornamented architecture. For such a man, it was easy to ignore or reject what was superfluous.

Hofmann's poetic insight into nature, and the metaphysical bent of his thought, no doubt reflect his national heritage; yet in no other sense could he be connected with German expressionism. Indeed in his love of light and brilliant color, his animal exuberance, the joy of living which his painting expresses, and his admiration for Matisse, he is more a fauve in spirit. Throughout his long career as a painter, teacher, and theorist, one would be hard pressed to find a stroke or word that is melancholy, bitter, ironic, or disenchanted. The morbid obsessions of expressionism and surrealism, and the desperate humor of Dada, therefore, were of little interest to him.

When one looks back at the years after 1945, when the "New American Painting" was taking form, it is apparent that one of its aesthetic determinants was the desire felt by many artists to incorporate in their work tendencies of style and feeling previously thought to be contradictory. Both the temper of Hofmann's mind and his supranational development led him in this direction. He admired Mondrian for the purity of his abstract structure, and also Kandinsky — whom he once called an "anti-plastic" painter — for his automatism and fluid color. The architectural basis of his own painting derives from a study of Cézanne, and from cubism, yet (at least in his representational paintings) he is probably as close to Matisse as he is to any other modern master. By synthesizing such diverse materials, Hofmann was able to pan his own variety of gold from the stream

Opposite:
Image of Cape Cod: The Pond Country, Wellfleet. 1961. Oil on canvas, 60⅛ x 52″. Samuel M. Kootz Gallery, New York

of modern painting: the unhampered autonomy of lines and planes; the elevation of color to a primary means; the maintenance of clear "intervals" between color planes; the preservation of physical gestures in pigment. He cast aside the dross of systematic perspective, tonal modeling, literature, and illusionism.

It it important that Hofmann's connection with art history be carefully studied; but art, in its finest achievements and experiences, rises above data and the sequence of events, even though, like a bird struggling to free itself, it is always entangled with history. Every scrap of Hofmann's painting, and every premise of his theory, points toward a timeless art, transcendent and monumental. On this basis he stands or falls. There is no middle ground, no lesser criterion for success or truth. Art for him has always been a total commitment entirely independent of style or fashion. Like philosophy, science, or religion it has been to him a means of probing nature, reality, and human experience—a goal shared with Euclid, Einstein, Beethoven, and Goethe (all of whom Hofmann reveres) as well as Rembrandt and Picasso. Not only is a work of art, as a unified field of relationships, akin to the universe; the universe itself is a work of art, and a model the artist must follow.

Although Hofmann is an abstract painter, his content is deeply human; and, if one responds fully, it is difficult not to feel soft winds, to hear the crash of storms, or to sense the animistic fury which some works contain. Each one, like a landscape, is an environment. Yet, whatever its human or natural content, the final aim for him, as it was for Matisse, is to provide aesthetic enjoyment. Although Hofmann is never an empty painter, he is always a pure painter.

Hofmann has always been moved to explain as well as create. While he taught, he gave every bit as much to his students as he now does to his canvases. To the many artists, now working in a variety of styles and media, who were his students, he was the only real art teacher of his generation. Erle Loran, himself a well-known painter and teacher, describes Hofmann as the "greatest teacher of painting and composition . . . since the Renaissance."[1] Yet, in one of the paradoxes that make up his genius, Hofmann the precise and rational theoretician was, as early as 1940, the painter who worked with more Dionysiac abandon, with more reckless poetic madness, than any other American artist.

In 1948, Hofmann wrote: "We are connected with our own age if we recognize ourselves in relation to outside events; and we have grasped its spirit when we influence the future."[2] It is still too soon to estimate accurately the scale of his influence; without question it was, and is still, enormous. It began in Munich during the twenties, when American students sought him out as the greatest art teacher in Europe; it was continued when, as a lone pioneer, he first taught in the United States in 1930, and it came to a climax with his radical canvases of the forties and his crowded classes in New York and Provincetown. Hofmann taught by explanation, by diagrams and sketches, by furious demonstrations, and, like a Zen **guru**, by shock. His students tell how he would sometimes tear their drawings in pieces, to reassemble from them new compositions. By infusing the atmosphere of the class with his own vitality, he inspired students to teach themselves and each other; he was able to implant in them something of his own prodigious creativity and energy, and some part of his belief in the essentiality of art to human culture. Hofmann's classes ended in 1958, but their influence continues.

It has been said that Hofmann is an "automatic" painter; he has also been called an "action painter" because of his direct enactment of emotional content. Yet his automatism has never been mere psychic catharsis, his activity is never purely physical, and his fury, like his delicate lyricism, is that of nature as well as himself. And even in the most passionate of his works the adjustment of formal relationships can be as precise as in the compositions of Mondrian or Malevich.

Hofmann's concentration of the modern tradition and his broad influence on abstract expressionism have already become history; but as an artist he was never younger, never more alive, never more forward-looking, than he is today. The forty paintings — most of them from the last decade — that make up the current exhibition and illustrate this text are therefore not presented as history, nor to demonstrate an artist's development, but solely for their beauty, profundity, and monumentality; for the purpose for which they were painted — delectation. And in the same spirit the text that follows presents, in a somewhat compressed form but whenever possible in Hofmann's own words, the basic premises of an aesthetic philosophy which is a unique combination of mysticism, introversion, faith, and intellectual precision. No concessions are made to the skeptic, nor to those who, from fear of art and life, are embarrassed by directly stated convictions. The significance of Hofmann's theory — in a tradition that includes the writings of Malevich, Kandinsky, Klee, and Mondrian — is comparable to that of his painting, and like his painting it opens the door to a truly spiritual view of art and life.

Tormented Bull. 1961. Oil on canvas, 60 x 83⅞". Owned by the artist

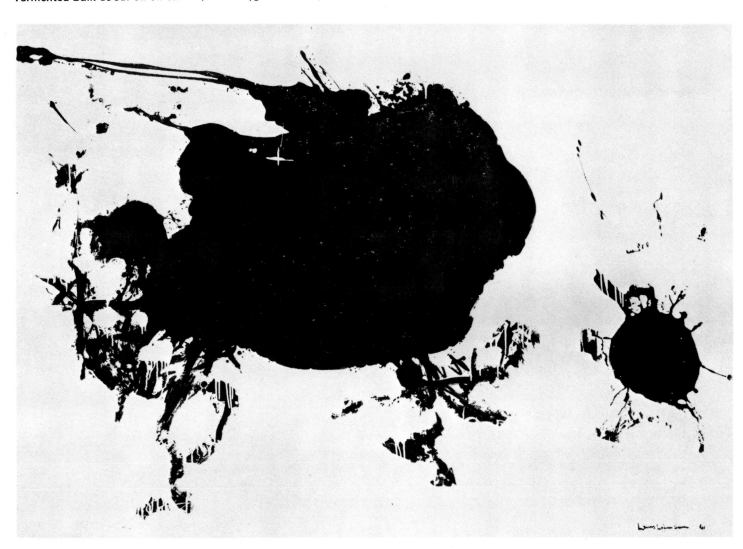

9

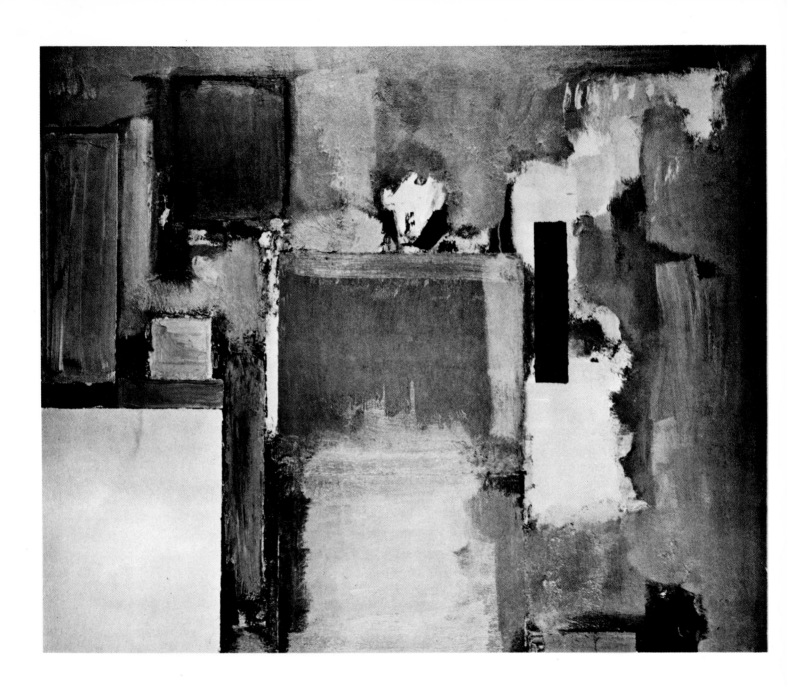

nature

The origin of art, for Hofmann, lies in nature. Whether a painter works directly from landscape or the figure, from memory, or from imagination, "nature is always the source of his creative impulses." Although Hofmann is generally thought of as an abstract painter, a philosophy of nature underlies every aspect of his art.

Solid objects are nature's most evident manifestation. Unlike some modern artists, Hofmann is attentive to physical bodies of all categories, from mountains and buildings to still life and the posed model, but he sees them simplified and essentialized: reduced to "the square, the cube, the cylinder, the sphere" (fig. 1). But, though the physical world is three-dimensional, objects in isolation are "artistically relatively meaningless" to Hofmann, for "we live in a world of volume and space." Objects ("positive" spaces or volumes) are always surrounded and invaded by unfilled or "negative" spaces: "the configuration, or 'constellation,' of the voids between and around portions of visible matter." Spaces are given form by the secondary, but important, outer surfaces of solids. The object therefore becomes a "space creator," and "surpasses by far its own physical limitation in its reflection on the environment." "Space has volume. Voids have volume, like objects. They have form and are as concrete as objects. The synthesis of positive and negative space produces the totality of space."

Prior to appearances, to objects, and to negative volumes, the first principle of nature is life itself. "Life does not exist without movement and movement does not exist without life." "Life-fulfilled form" and "force-impelled space" interlock. Space is "filled with movement, with forces and counterforces, with tensions and functions, with colors and light, with life and rhythm, and the dispositions of sublime divinity." And "the whole world, as we experience it visually, comes to us through the mystic realm of color. Our entire being is nourished by it." "Form exists only by means of light, and light only by means of form." Color is an effect of light, which is never static.

Following this interpretation, even Hofmann's most abstract paintings can be seen as a dialogue between stripped "objects," — often rectangles of color — and volumes which, though "negative," are nevertheless energized and illuminated, and thus filled. These works do not represent nature, but follow its principles: here is the link

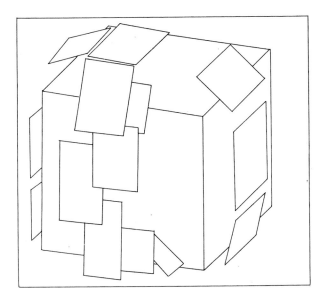

Fig. 1. Hofmann's diagram of a single object in nature reduced to a basic form (the "basic forms" are "the square, the cube, the cylinder, the sphere"). External surfaces move around the central volume, creating surface tension and establishing the limits of "negative" volumes between objects.

Opposite page:
The Golden Wall. 1961.
Oil on canvas, 60 x 72¼".
The Art Institute of Chicago,
Mr. and Mrs. Frank G. Logan
Purchase Prize Fund

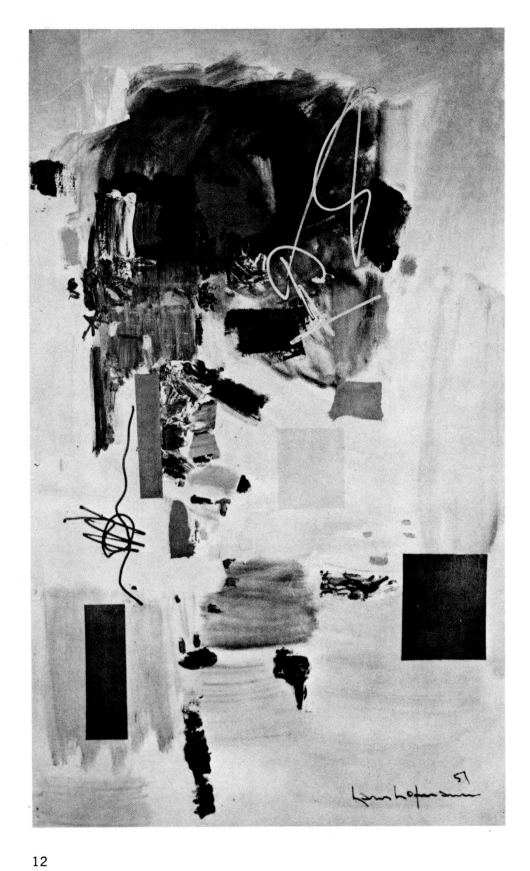

12

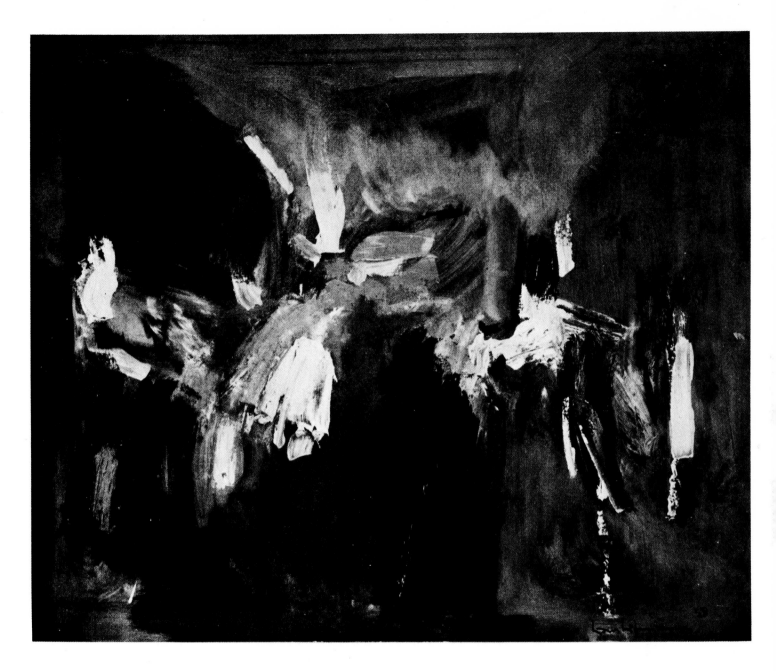

Above: **Festive Pink.** 1959. Oil on canvas, 60 x 72"
Collection Miss Vera Vio, Rome

Opposite: **Golden Splendor.** 1957. Oil on canvas, 84 x 50".
Collection Mr. and Mrs. Joseph H. Hazen, New York

that relates Hofmann's abstract painting to nature, whose function goes far beyond supplying objects to be imitated and arranged. Nature is the stimulus to create, and the model for the artist's creativity: "stimulus in the sense of enlivenment and profound visual experience. Nature provides this stimulus through its creative behavior. From its ceaseless urge to create springs all life — all movement and rhythm — time and light, color and mood — in short, all reality in form and thought."

perception: reality, appearance, effect, empathy

Unlike the scientist, whose concept of nature has become increasingly divorced from sensory experience, the artist before everything else must be a perceiving subject. "All our experiences culminate in the perception of the universe as a whole with man at its center." He is a part of nature, incapable of escaping from it. The painter's first responsibility, therefore, is to "learn to see." Claude Monet, in his desire to paint the world as his eyes responded to it, tried to free vision from adulteration by memory and emotion. If such purified eyesight — which, in the end, is all but hypothetical — could be achieved, Hofmann would consider it insufficient for the artist; a reduction of nature to "the mere stimulus of the optic nerve by light." But he knows that human eyes perceive a two-dimensional screen of colored patterns: "Actually we see only the appearance of things. Our vision is two-dimensionally oriented, but reality is three-dimensional." The impressionists, as Hofmann observes, attained "unity of light," and "led painting back to the two-dimensional."

Hofmann places great emphasis on a sharp distinction between "reality" and what he terms "appearance": the two-dimensional image available to sight. "Light and shade do not always convey the truth about form. . . . Only by the aid of our other senses do we gain a proper understanding of the particular form we have before us." "Spatial nature is not two-dimensional — it only appears to be so." And, on the other hand, though the appearance of reality in vision is flat, it gives an effect of three-dimensionality in expanded perception. Painting therefore should not be based on vision alone, for "seeing with the physical eyes borders on blindness. We see, indeed, with all our senses. All our senses are dependent upon each other in their action upon the mind where they join and overlap. . . ."[3] Such titles as **Fragrance** or **The Whisper of the South Wind** (color pl. 8) indicate Hofmann's belief that creative observation of nature should draw on hearing and touch, as well as on the uncanonized senses of space and movement. "Inner vision" is his term for such consciously enriched perception — a synthesis of all avenues of communication from environment to man.

> By putting to use our power of spiritual projection, our emotional experiences can be gathered together as an inner perception by which we can comprehend the essence of things beyond mere, bare sensory experience. The physical eye sees only the shell and the semblance — the inner eye, however, sees to the core and grasps the coherence of things. The thing, in its relations and connections, presents us effects that are not real but rather supersensory. . . . Therein lies, as far as we are concerned, the . . . essence of the thing. By means of our inner perception, however, we grasp the opposing forces and the coherence of things. . . .

The faculty of "feeling into," or empathy, is related to inner vision. Hofmann defines empathy as "the imaginative projection of one's own consciousness into another being or thing." Applied to visual experience, "it is the intuitive faculty to sense qualities of formal and spatial relations, or tensions. . . ." By concentrating in the supersense of empathy data from all the senses, from past experience, and emotion, mere appearance gains an effect that is a counterpart, created by the perceiver, of the three-dimensionality, vital force, and spatial unity of nature.

the artist

Hofmann may well be the most experienced and successful teacher of painting of this century. The demanding and explicit standards he sets for the artist should therefore be regarded thoughtfully. Contact with hundreds of students has convinced him that an artist is born, and must possess a degree of intuition, profundity, and superiority of mind that cannot be taught.

Within a more limited compass, the most ordinary perception of the world is creative in unconsciously integrating material drawn from several sources into a coherent whole. When accompanied by a high degree of empathic projection—by "awareness"—perception even approaches art. Such sensibility, Hofmann believes, is "the source of creation."

Heightened perception initiates the creative process, but to approach a higher level of creativity, sensibility must be applied intentionally: "Every real artistic expression that can lay claim to quality is the product of conscious feeling and perception." The greatest works of art are those approached through "the consciousness of the experience." The difference between great art and the art of children, therefore, is that "one is approached through the purely subconscious and emotional, and the other retains a consciousness of experience as the work develops and is emotionally enlarged through the greater command of the expression-medium."

Although the objective observation employed by the scientist is also conscious, it is a danger to the artist. Scientists deal with experiences that occur "repeatedly in the same manner," whereas "creation cannot live on repetitious experience because life is in every instant always new." "The scientist analyses intellectually; the artist emotionally and aesthetically."

Art must be initiated by feeling and emotion. In the mind of the artist, which operates by intuition rather than by reason, "dreams and reality are united." But he is able to create "only after he has effective command of his faculty of empathy, which he must develop simultaneously with his imaginative capacity."

In the context of Hofmann's philosophy the artist's creativity is all but inseparable from that of nature; he is "an agent in whose mind nature is transformed into a new creation." His metaphysical power, his ability to sense the inherent qualities of things, are aspects of a natural creative function. By the same token, painting is theoretically "a process of metabolism, whereby color transubstantiates into vital forces that become the real sources of painterly life." Because of his heightened perception and the profundity of his experience the artist is seldom a materialist; he "cares relatively little about the superficial necessities of the material world."

creation

"Creation is dominated by three absolutely different factors: first, nature, which affects us by its laws; second, the artist who creates a spiritual contact with nature and with his materials; and third, the medium of expression through which the artist translates his inner world." Of these three components only one, the medium, is material. Creation in painting is thus, first, the power to experience through the faculty of empathy, and second, the ability to infuse the physical medium of expression with spiritual life. After the canvas or panel is primed, therefore, no incident in the process of painting is mere mechanics, preparation, or craftsmanship. Every touch demands the artist's fullest intuitive and synthetic power, projected toward nature on the one hand, and toward the medium on the other. No matter how many phases the work may pass through from first sketch to final realization it should be a work of art at each. At every point "plastic

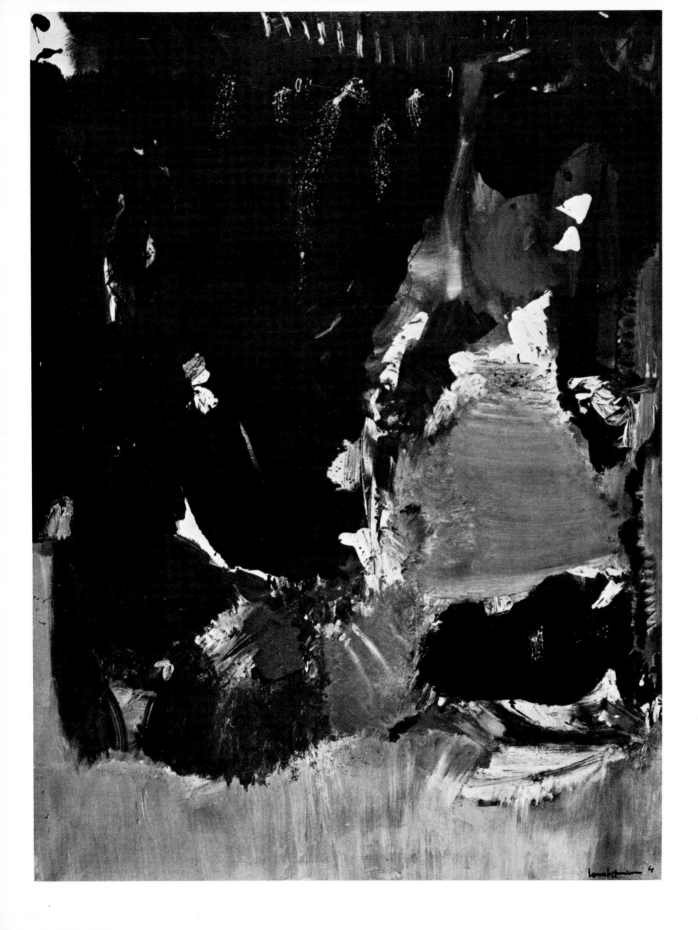

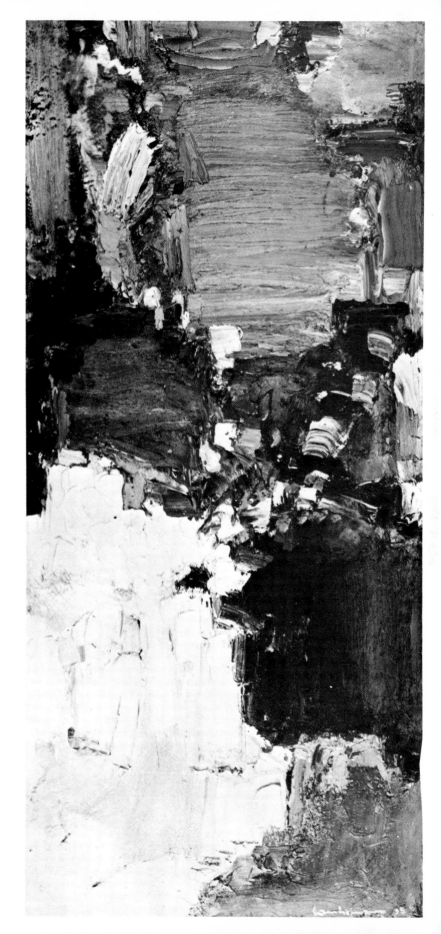

Right: **Rhapsody.** 1958.
Oil on plywood, 71⅞ x 32″.
Owned by the artist

Opposite:
". . . and thunder clouds pass"
(Nikolaus Lenau). 1961.
Oil on canvas, 84⅛ x 60¼″.
Owned by the artist

creation asks for feeling into the essentiality of nature as well as feeling into the essentiality of the medium of expression. The plastic experience gained by the former must be transformed into the plastic language of the other. Nature cannot be copied. A continued counterbalancing from one feeling aspect to another determines the quality of the work. It involves the whole sensibility and temperament of the artist.''

Needless to say, creation is much more than arrangement. Arrangement is not true composition, ''and, therefore, it is not art.'' ''A pictorial decorative arrangement is dictated only by taste — which is, after all, only a passing fad, or fashion.'' Neither are representation, history, allegory, or symbolism art. All such aims and accomplishments — though not inimical to creative painting — are outside the artist's real problem, which is entirely pictorial.

the medium[4]

The difference between the arts arises because of the difference in the mediums of expression, and in the emphasis induced by the nature of each medium. Each means of expression has its own order of being, its own units.

Some degree of insight into reality is shared by all artists, whatever means and materials they employ. Between reality and art stand materials to be carved, molded, or assembled for the sculptor, bodily forms and movements for the dancer or choreographer, sounds for the composer, words for the poet, papers or other material for the collagist, canvas and pigment for the painter. The artist must be able to translate his feeling into the medium of his choice, for ''to explore the nature of the medium is part of the understanding of nature, as well as part of the process of creation.''

The inherent qualities of the medium must be surely sensed and understood if it is to become the carrier of an idea. And the idea must be transformed and adapted to the medium's inner quality, not simply to its external attributes. Although ''the same formative idea can be expressed in a number of different mediums,'' a musical idea should be expressed by musical means, a literary idea by literary means, and a painterly idea by ''plastic'' means.[5]

The reality that confronts the painter before he begins to paint is double: radiating outward from his senses and his mind in every direction is the world and the universe; before him — as much an object as is a tree or a book — is his canvas. It is flat and usually rectangular. Hofmann's ''first law'' of the medium is therefore in force before the painting process begins: ''The essence of the picture is the 'picture plane.' '' But the picture plane is identical with the material painting surface only before the first mark has been made upon it. As a work develops, the second — a physical object — is absorbed into the first — a translucent relational screen, perceptual and metaphysical.

The transformation effected by the plastic painter is the reverse of that accomplished by eyesight, which transforms three-dimensional reality into two-dimensional appearance. Using a two-dimensional means, accessible only to sight, he must bring into being a three-dimensional effect capable of awaking a full range of intellectual, emotional, and sensory experience: ''A work of art is plastic when its pictorial message is integrated with the picture plane, and when nature is embodied in terms of the qualities of the expression-medium.'' As the work proceeds, ''a thought that has found a plastic expression must continue to expand in keeping with its own plastic idiom. . . . Neither music nor literature is wholly translatable into other art forms; and so a plastic art cannot be created through a superimposed literary meaning. The artist who attempts to do so produces nothing more than a show booth. He contents himself with visual storytelling. He subjects himself to mechanistic thinking which disintegrates into fragments.''

18

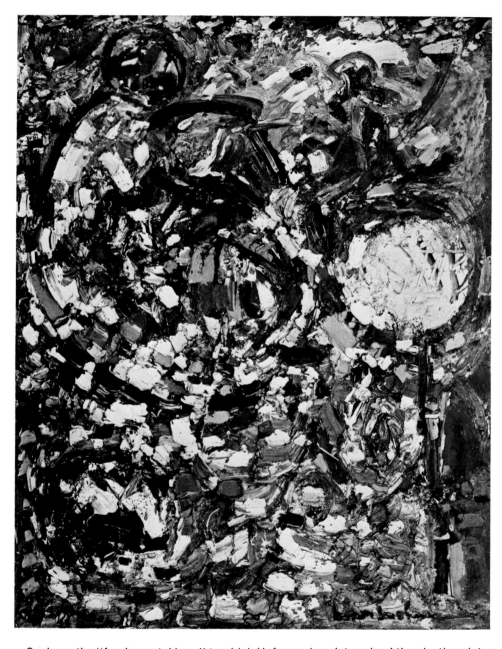

The Garden. 1956.
Oil on plywood, 59⅞ x 46¼".
Owned by the artist

Such are the "fundamental laws" to which Hofmann has determined the plastic painter must adhere; yet by his own requirements they cannot be systematically applied in any specific work, or even rationally followed. "At the time of making a picture," he once said in characteristic defiance of his carefully formulated precepts, "I want not to know what I'm doing; a picture should be made with feeling, not with knowing." [6] Asked how he actually approaches his painting, he answers thus: "I hold my mind and my work free from any association foreign to the act of painting. I am thoroughly inspired and agitated by the actions themselves which the development of the painting continuously requires. From the beginning, this puts me in a positive mood, which I must persistently follow until the picture has found realization through paint. This seems simple, but it is actually the fruit of long research."

19

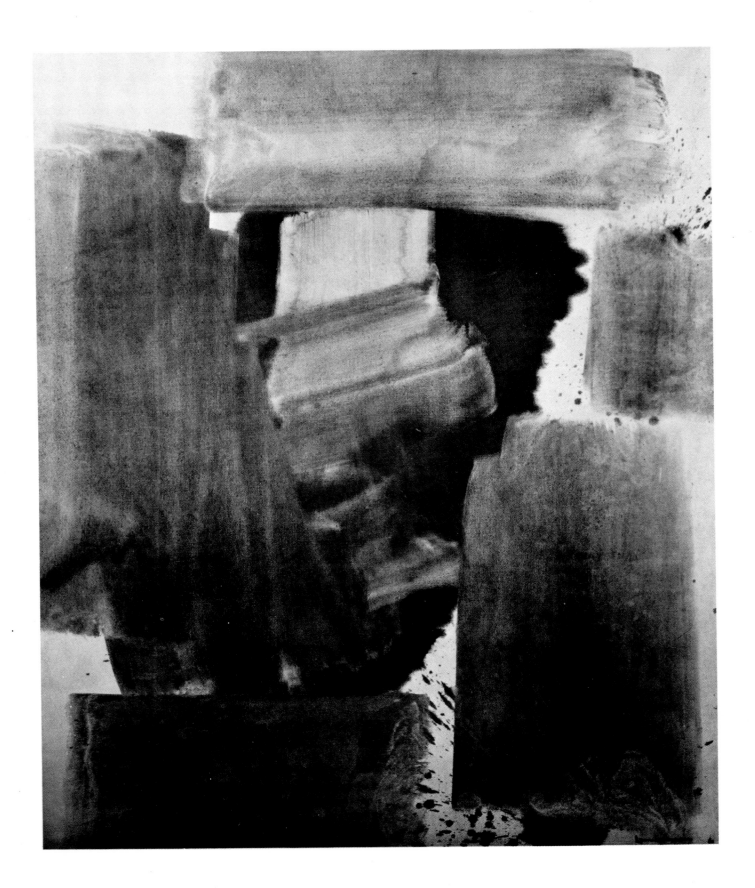

the picture plane

Throughout history — even within the pictorial conventions of such styles as those of Assyria and Egypt — painters have tried to create an illusion of solidity and depth on a two-dimensional surface. Hofmann has never abandoned this traditional aim. But both his feeling for nature and his development within the postimpressionist tradition have led him to disdain the methods of representing space employed by most Renaissance and post-Renaissance masters. Depth should not be simulated by "the arrangement of objects one after another toward a vanishing point," nor by tonal gradation. These devices violate Hofmann's first law of painting: "The picture plane must be preserved in its two-dimensionality throughout the whole process of creation until it reaches its final transformation in the completed picture."

It is impossible to overemphasize the importance which he delegates to the surface of the canvas. It must never be hollowed out like a stage nor treated as a box into which painted objects can be placed. He regards it, rather, as an instrument which responds like a harp to each touch of the player. Over and over in his writing he emphasizes his concern not only for preserving the picture plane, but also for the two vertical and two horizontal lines which delimit it. Any line placed on the canvas is already the fifth. He has shown that the smallest mark, placed on a virgin surface, will establish an immediate tension between its two-dimensional location and an implied position and movement in depth. One touch can therefore transform flatness into space, and yet, by means of a mysterious and beautiful paradox of perception, leave the picture's surface tension inviolate. Such an effect can be achieved even by an accidental stroke, but it can only be expanded, sustained, and developed by a plastically sensitive artist. He must keep the unfolding space-in-flatness from becoming confused, and avoid "holes" that might destroy the picture plane by depth which is "a naturalistic imitation of nature" and hence not pictorial.

Only an advanced psychology of perception could explain in detail the interrelated factors of vision and experience that contribute to the simultaneity of flatness and space in Hofmann's canvases. As an artist and former teacher, he prefers to describe what takes place rather than to fragment it by scientific analysis. When the brush or knife, animated by the painter's hand, touches the picture surface, the surface answers automatically with a counterimpulse. The picture's "radar-like three-dimensional response" is "dominated by inherent laws which respond plastically with the highest precision to such animation." So conceived, painting is not representation, even though its forms may resemble real objects, but a continuing dialogue between painter and medium.

pictorial elements

Wassily Kandinsky's second book bears the title **Point and Line to Plane.** It is a convenience to discuss these pictorial elements as if they were always separated, even though in practice they are often fused and intermixed. With the sizable addition of a diversity of strokes, spots, gradations, modulations, freely shaped areas, drips, spatters and combinations of these, they are the basic elements of abstract painting, which, when properly utilized, produce form.

Hofmann differentiates between a line and a plane concept. He regards points and lines as secondary means. Unlike such painters as Klee, Tobey, or Pollock, he has used line sparingly since the 1940s and primarily as a final accent, embellishment, or emphasis of movement. It could be said indeed that—perhaps because he associates "line" with the hard contours of neoclassical and academic painters—Hofmann underestimates

Opposite: **Agrigento.** 1961. Oil on canvas, 84 x 71¾". Owned by the artist

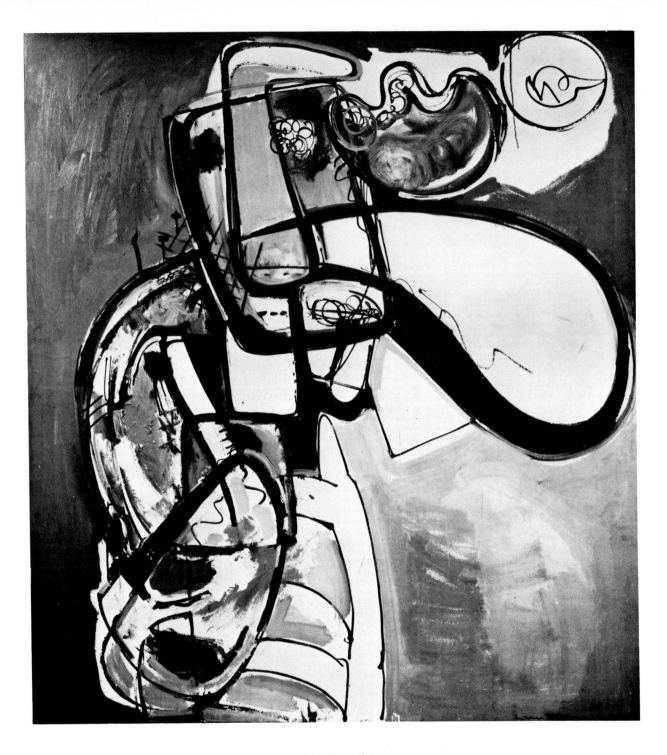

Above: **Ecstasy.** 1947. Oil on canvas, 68 x 60". Owned by the artist

Opposite: **Image of Fear.** 1960. Oil on canvas, 84 x 60". Samuel M. Kootz Gallery, New York

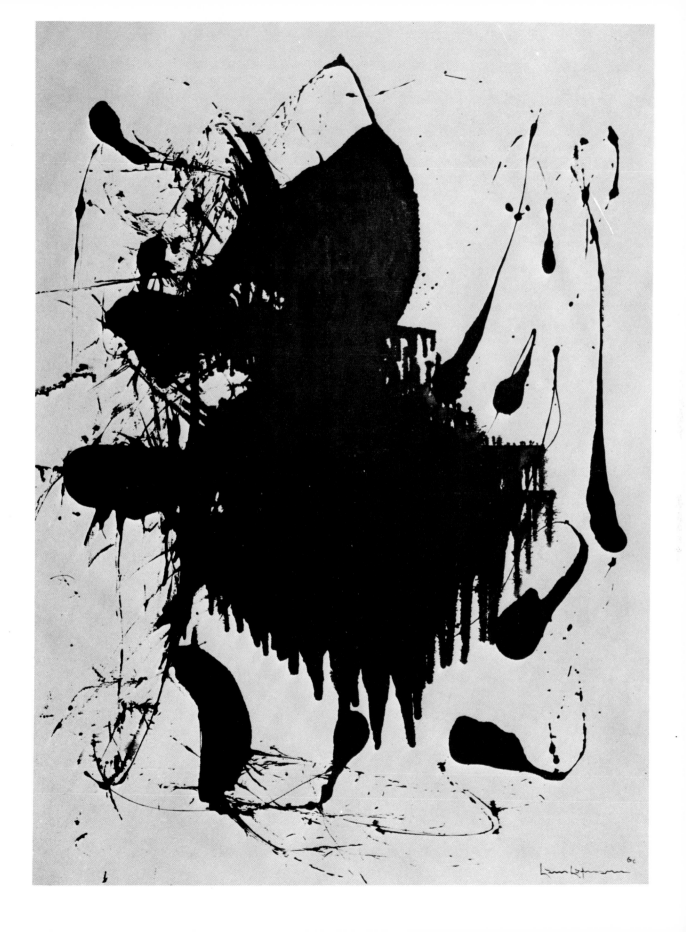

its potentiality: "A work based only on a line concept," he writes, "is scarcely more than an illustration; it fails to achieve pictorial structure." "A line concept cannot control pictorial space absolutely. A line may flow freely in and out of space, but cannot independently create the phenomenon of 'push and pull' necessary to plastic creation."

The formative period of Hofmann's development, it should be remembered, was in the milieu of early cubism, and his visualization rests on an architectonic foundation. Viewed in the light of his structural concept, lines originate as outlines — i.e., edges — where planes meet. "The course of a spatially conceived line develops from different positions in a multitude of planes"; in its course it "always touches or passes over a number of space-planes." The line serves to confine a plane or painted area; "as outline it divides and combines; as an aesthetic carrier it flows," and becomes "the vehicle of free, searching effects."

The plane, to Hofmann, is the primary pictorial element of painting as well as of sculpture and architecture. "Cubism was a revolution in that the artist broke with tradition by changing from a line to a plane concept." The Renaissance and Baroque masters whom Hofmann admires, such as Piero della Francesca, Michelangelo, and Rembrandt, were great in part because they also were "plane conscious." Each plane "is a fragment in the architecture of space. When a number of planes are opposed one to another, a spatial effect results. A plane functions in the same manner as the walls of a building. A number of such walls in a given relation creates architectural space in accordance with the idea of the architect who is the creator of this space." "Planes," Hofmann says, "are the pillars of the space of my own creation."

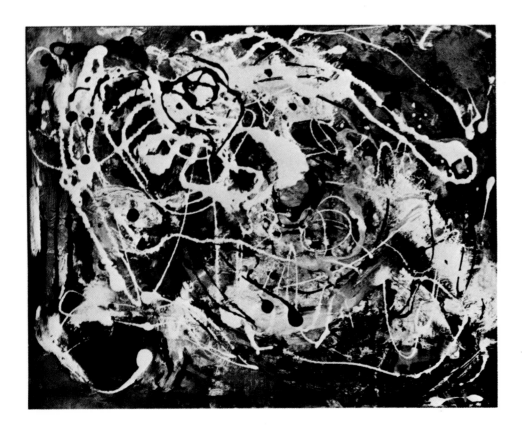

Left: **Spring.** 1940.
Oil on wood, 11⅜ x 14⅜".
Collection Peter A. Rübel,
Greenwich, Conn.

Opposite: **Fantasia.** 1943.
Oil on plywood, 51½ x 36⅝".
Owned by the artist

24

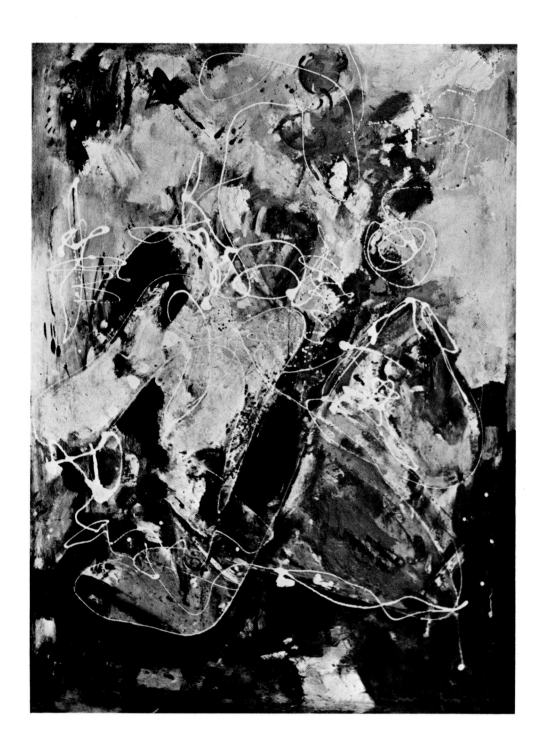

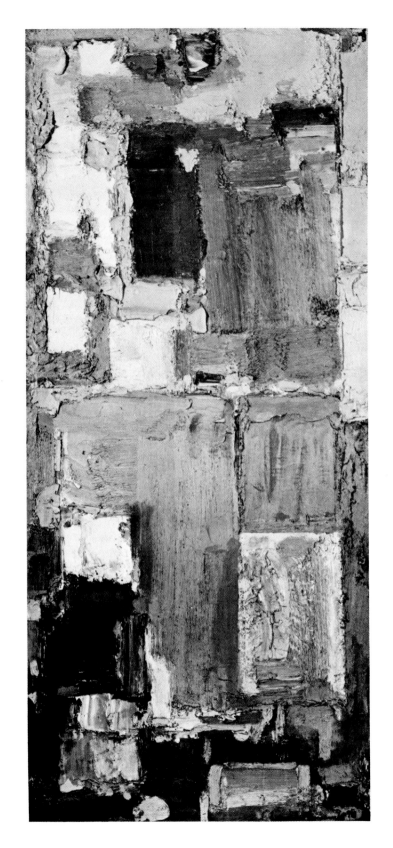

Kaleidos. 1958.
Oil on plywood, 72⅛ x 31⅞".
Owned by the artist

push and pull

The mystery of plastic creation is based upon the dualism of the two-dimensional and the three-dimensional.

The term "push and pull," which Hofmann originated to designate the simultaneous operation of flatness and depth, has become famous. It is a phenomenon central to much of the greatest painting of the last half century: "Only from the varied counterplay of push and pull, and from its variation in intensities, will plastic creation result." "Push is answered by pull, and pull with push."

Eyesight (as distinguished from expanded perception) compresses the three dimensions of reality into the two dimensions which make up appearance. In the mind this screen of colored light has a volumetric effect. Because drawing paper and canvas are flat, the "appearance and the picture plane are identical in their essence." As a physical fact, a painting is made up of variously colored and toned arrangements of points, lines, and areas within a rectangle. If a plastic result is to be achieved, Hofmann points out, two opposing pitfalls must be avoided: on the one hand a flatness which is passive and empty, and on the other a depth which is imitative and sterile. The untouched canvas is empty,[7] but a "touched" canvas can be empty also: "Such will be the case when the picture surface is only tastefully used as carrier of a superposed ornamental design." Instances of passive flatness are all around us in decoration and commercial art (and in works by certain so-called "pop artists," who emulate the banality of advertising and commercial illustration). Such painting signifies to Hofmann "either plastic ignorance or total emptiness." When he speaks of "empty flatness," therefore, he means "empty of plastic content." The opposite danger — the imitation of real depth and bulk by the use of Renaissance perspective and tonal modeling — "makes the picture surface into an immense hole in the architectural wall. Renaissance perspective has only one direction into depth. Depth does not answer back pictorially. This produces a sterile space which is the exact opposite of pictorial space. The mirror also (like bad painting) produces only the illusion of 'naturalistic' space." At best, illusionism "represents a special case," comprising only "a portion of what is felt about three-dimensional experience."

Like the dualism of reality and appearance in nature, plastic creation is spatially divergent. Forced by his medium to operate solely through the spectator's vision, the painter must achieve plasticity while "activating," but never violating, the picture's two-dimensionality — logically impossible though this feat seems to be. "What we experience in nature 'conceptually' as depth transforms on the picture surface into an act of shifting [fig. 2, page 30]. The physical carriers in the act of shifting are the pictorial means employed. . . ." Every two-dimensional shift on the picture surface also entails a volumetric assertion. To Hofmann this two-valued, aesthetically created space is as real, in its way, as that of nature: a phenomenon based on "the reality of the hidden inherent laws of the picture surface." The maintenance of flatness thus never means the exclusion of depth, "It means on the contrary one hundred per cent realization of three-dimensionality and not a jot less. The potential of one hundred per cent three-dimensionality is two-dimensionality."

A more easily understood consideration of space may be found in Hofmann's observations on positive and negative space in sculpture — a medium much closer than painting to the reality of nature:

All basic forms exist as volumes. A volume is a more or less complicated plane formation. The characteristic of a plane is its two-dimensional surface. Planes move around

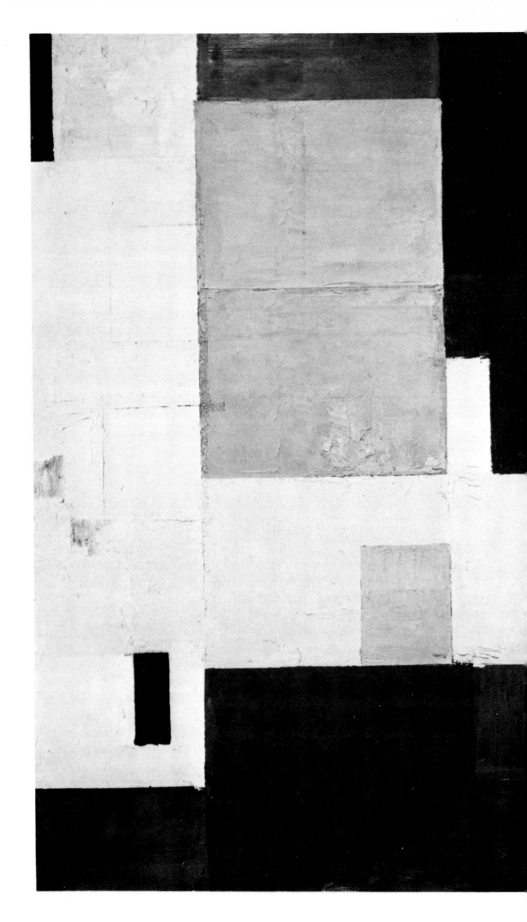

Combinable Wall. 1961.
Oil on canvas
Owned by the artist
right: Part I, 84⅜ x 60¼"
left: Part II, 84¼ x 52¼"

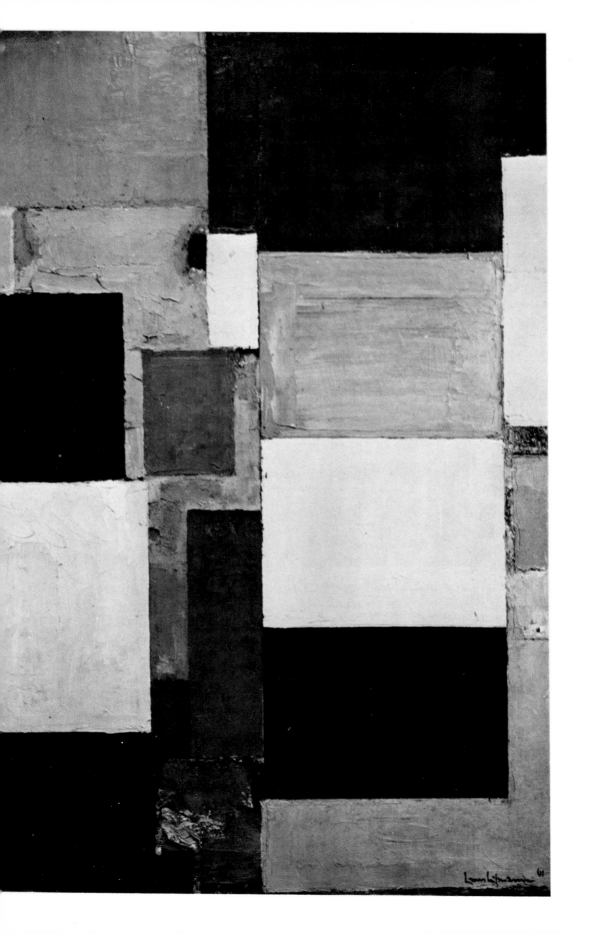

and thereby define a basic form. The manifold movements of all planes surrounding the kernel of a basic form [cf. fig. 1] create an active and vital plastic volume.

We have defined a physical volume as a more or less complicated plane formation. A multitude of such volumes offers, of course, considerably more difficulties for plastic analysis. . . .

Sculpture deals with basic forms. The basic forms are: cubes, cones, spheres and pyramids. Every subject has a characteristic basic form. . . .

Volumes penetrate each other and in this way are no longer single formations. When two or more volumes penetrate one another, a totally new form is created.

Basic forms are positive space volumes; negative space is created through the opposition of these positive space volumes. Positive space is life-fulfilled — negative space is force-impelled. Both exist simultaneously — both condition each other — neither is conceivable without the other. Only the simultaneous existence of positive and negative space creates a plastic unity.

When, in discussing painting, Hofmann states that "form must be balanced by space," that form and space must "exist together in a three-dimensional unity," he could be talking of sculpture, or even of space in nature. But when he concludes that spatial unity is represented by "the two-dimensional unity of the picture plane," another medium and aesthetic realm has been entered; space and flatness must exist simultaneously and, consequently, in tension.

Many of Hofmann's recent works (pages 28-29, 31, 34; color pl. 7) are built up entirely or in part from large rectangular planes of color aligned parallel to the picture plane. He is acutely concerned with the distance that separates these planes, and whether they touch or overlap. On this score he distinguishes between opposing modes: one in which "the element of overlapping plays a predominant part in the pictorial development," and another, in which "the element of overlapping is entirely removed and replaced by the element of shifting," that results in a more equivocal push and pull. In

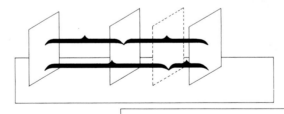

Fig. 2.

Diagram, after Hofmann, showing the transformation of spatial tensions as they exist in nature (above) into pictorial relationships achieved through "the act of shifting" on the picture surface (below). A forward movement of the plane in the center is indicated by dotted lines in both diagrams, demonstrating that a shift on the canvas of a "fragment of a millimeter" can be the equivalent of a great distance forward or backward in nature. A slight change in two-dimensional position can therefore have a tremendous influence, not only on the effect of depth and space, but also on the "total play of effective forces in the picture."

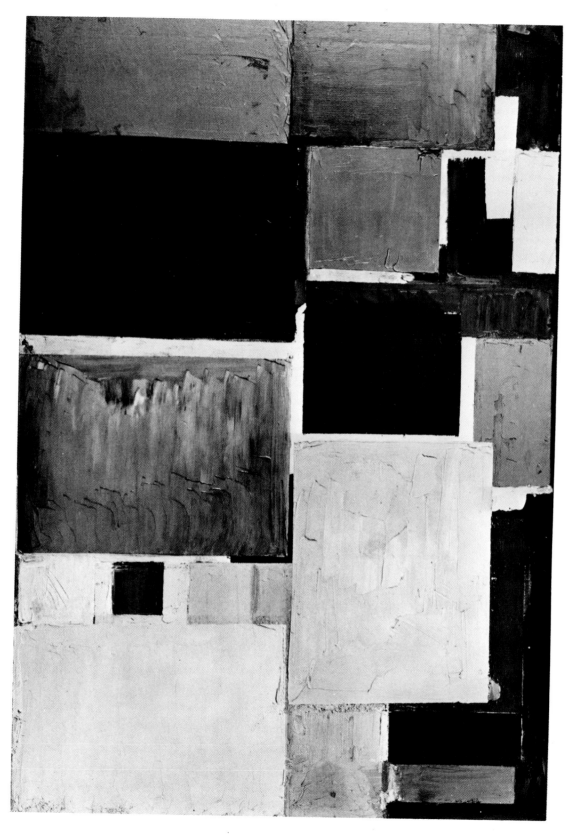

Cathedral. 1959.
Oil on canvas,
74⅛ x 48⅛".
Owned by the artist

recent years he most often employs the less obvious, more optically variable method of juxtaposing elements that do not overlap.

It was through long experience as an artist and teacher that Hofmann learned that depth in nature transforms into an act of formal shifting. "The totality of sensitive controlled shifting actions produces finally the coexistence of a produced depth rhythm and a two-dimensional surface rhythm, and with it a new reality in the form of pictorial space." The result is a continual mediation and tension between alternatives, so that the nouns "space" and "flatness" become all but synonymous with the verbs "push" and "pull." Plastic depth is thus never static, but, like natural depth, is active. "The movement of a carrier on a flat surface is possible only through an act of shifting left and right or up and down. To create the phenomenon of push and pull on a flat surface one has to understand that by nature the picture plane reacts automatically in the opposite direction to the stimulus received; thus action continues as long as it receives stimulus in the creative process."

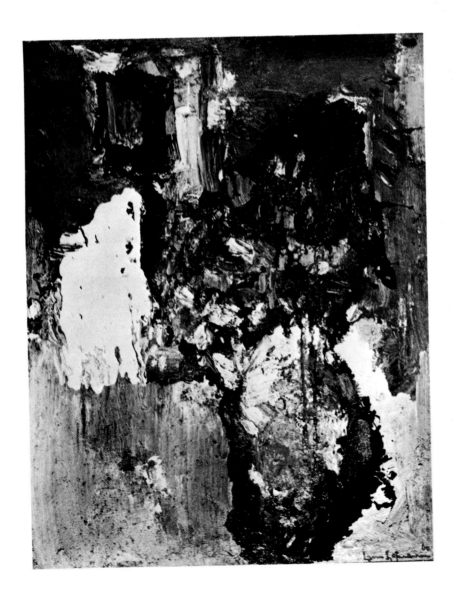

Left: **Black Goddess.** 1960.
Oil on canvas, 48⅛ x 36⅛".
Owned by the artist

Opposite: **The Gate.** 1960.
Oil on canvas, 74⅝ x 48¼".
The Solomon R. Guggenheim
Museum, New York

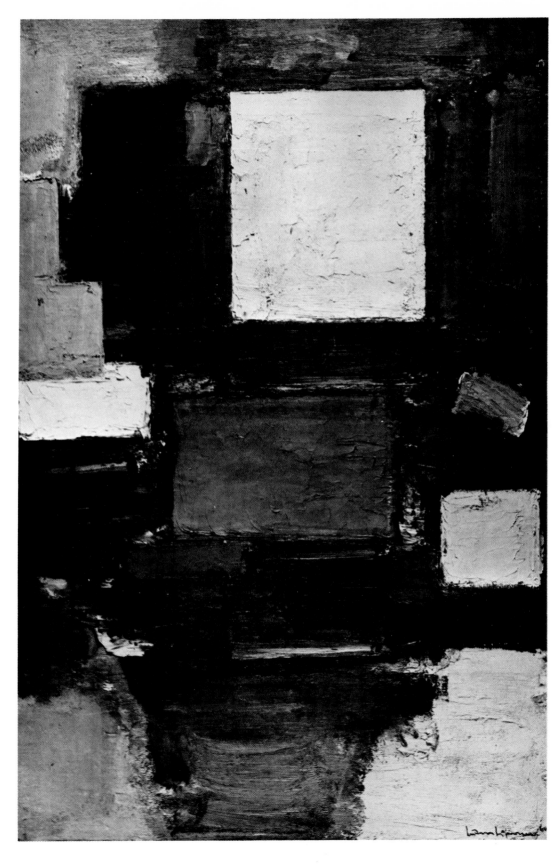

33

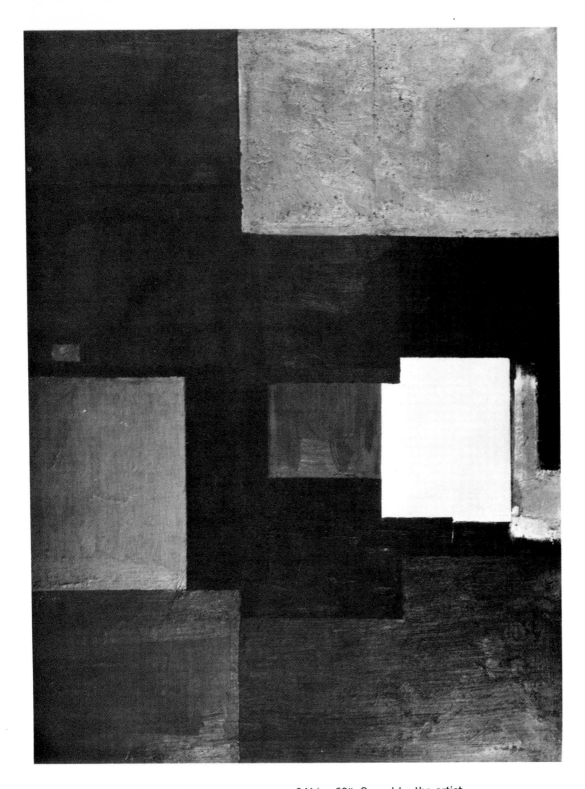

Above: **Ignotum per Ignotius.** 1963. Oil on canvas, 84¼ x 60". Owned by the artist

Opposite: **The Phantom.** 1961. Oil on canvas, 84 x 72". Private collection, New York

34

Above: **Blue Rhapsody.** 1963. Oil on canvas, 84 x 78″. Owned by the artist

Opposite: **The Prey.** 1956. Oil on composition board, 60 x 48⅛″. Owned by the artist

36

movement

Hofmann once spoke of making a picture as "almost a physical struggle."[8] Whether judged by his work of the last twenty-five years, by his theory of painting, by his method of teaching, by his ebullient personality, or by his intensely active working procedure, he is among the most dynamic painters of his time. Nature, life, and art to him imply energy and movement before anything else.

> Every expression-medium can, in consequence of the impulse received by nature, be made to vibrate and resound. The intensity of the enlivenment that the expression-medium receives depends solely on the facility for emotional experiencing in the artist, which in its turn determines the degree of spiritual projection into the nature of the expression-medium. . . . The question of "what" shall be brought into spiritual expression in the creation is always preceded by this requirement.

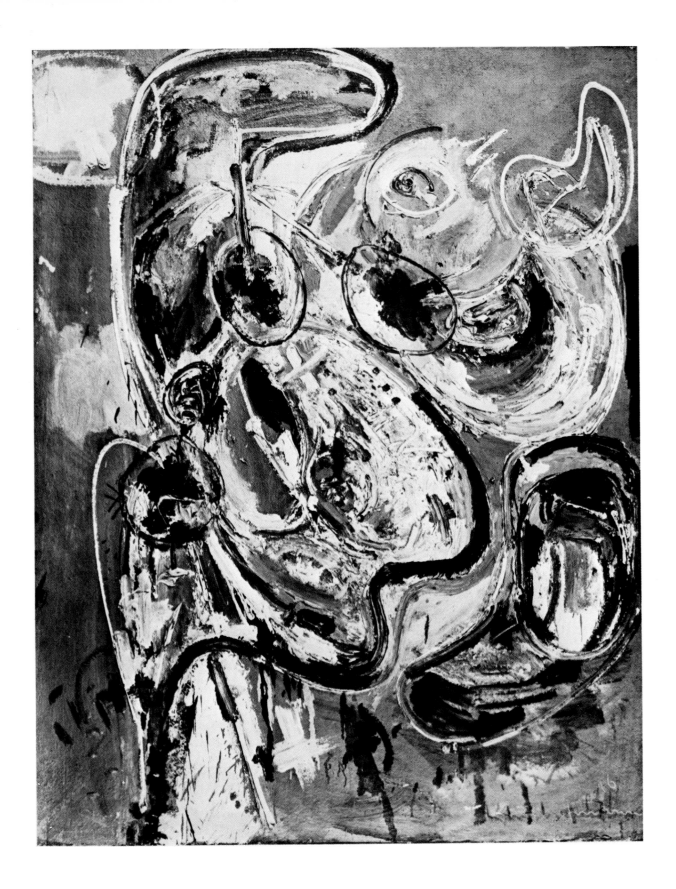

The act of creation animates the picture surface, but, just as the depth created on it is not actual but is an effect of visible relationships on the mind, so "one cannot produce any real motion in the picture plane but rather only the illusion of motion." "Plastic animation 'into the depth' is answered with a radar-like 'echo' out of the depth and vice-versa." The impulse and echo of push and pull establish "two-dimensionality with an added dynamic enlivenment of created breathing depth." In creating space and movement simultaneously, the painter intuitively parallels the equivalence of energy and matter that the scientist has verified and demonstrated: "Space is all energy. Without this energy space would be nonexistent. The inherent vital forces of space cannot be visually detected, but we are able to sense them in the life that they create. This life, of which we are all a part, influences us and stirs our imagination, to make it the stimulus for the creation of pictorial life." Unlike perspective depth, which is based on systematic diminution of size, plastic depth, created by variable factors such as position, relative size, and the competition of colors, is visually dynamic. So out of a feeling of depth, a sense of movement develops.

> There are movements that swing into the depths of space and there are movements that swing back out of the depths of space. Every movement (in space) releases a counter-movement. . . . Movement comes into the appearance primarily by means of a counter-movement. Movement and countermovement produce tension, and tension produces rhythm. Tension is always the expression of a ratio . . . of forces.
> A represented form that does not owe its existence to a perception of movement is not a form, because it is . . . spiritless and inert. The form is the shell of life. . . . Form has its most complete expression in the fullness of life, and it disappears when life ends. When life ends, cold dead space ensues, and when form goes we have only unpresentable nothingness.

The creation of plastic movement, it is probably unnecessary to add, is in no way dependent on the depiction of futuristic subjects such as running horses or speeding automobiles: "Aesthetic form can exist solely through animation of the pictorial means. This is the aesthetic justification for nonobjective art. It is the animation of the pictorial means — not the animation of the object — that leads into pictorial over-all animation. The pictorial realization and animation of the object will result from a step-by-step development of such an over-all animation." Hofmann does not take advantage, at least to an equal degree, of all the formal means of suggesting movement available to the painter. As indicated on page 21, he seldom uses line to create continuity of movement— this he does with planes. He allows line to function only as an enrichment within the total pictorial development, as a heightening of expression in a lyrical or dramatic sense, or as an outburst of rhythmic exuberance.

Most characteristic are those carriers of movement which exist in opposition. "Expansion and contraction in a simultaneous existence," he writes, "is characteristic of space." The creation of recession within flatness generates movement not only in the sense of push and pull, but also in the intensity and speed with which depth penetration and its counterecho are varied. He illustrates the rhythmic operation of push and pull metaphorically as an inflated balloon: By pushing one side the balance is disturbed, "and as a consequence, the other side will swallow up the amount of pressure applied."

Considered as opposition even immobility is an aspect of movement: "The most dynamic swings back to the static," for "there can be nothing static to the exclusion of the dynamic and vice-versa. In that way we comprehend nature as a unity out of opposites and relationships."

The scale of Hofmann's major canvases is often monumental, so the suggested span between their elements can be great, the tensions high and the rhythm slow and

Opposite: **Bacchanale.** 1946.
Oil on cardboard, 63½ x 47⅞".
Owned by the artist

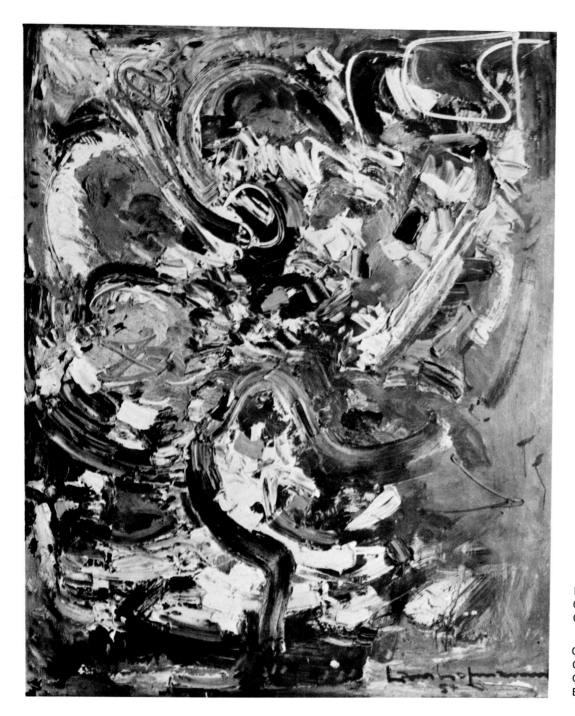

Left: **Liebesbaum.** 1954.
Oil on plywood, 60⅞ x 30".
Owned by the artist

Opposite: **Wild Vine.** 1961.
Oil on canvas, 72 x 60".
Collection Mr. and Mrs. David
E. Bright, Beverly Hills

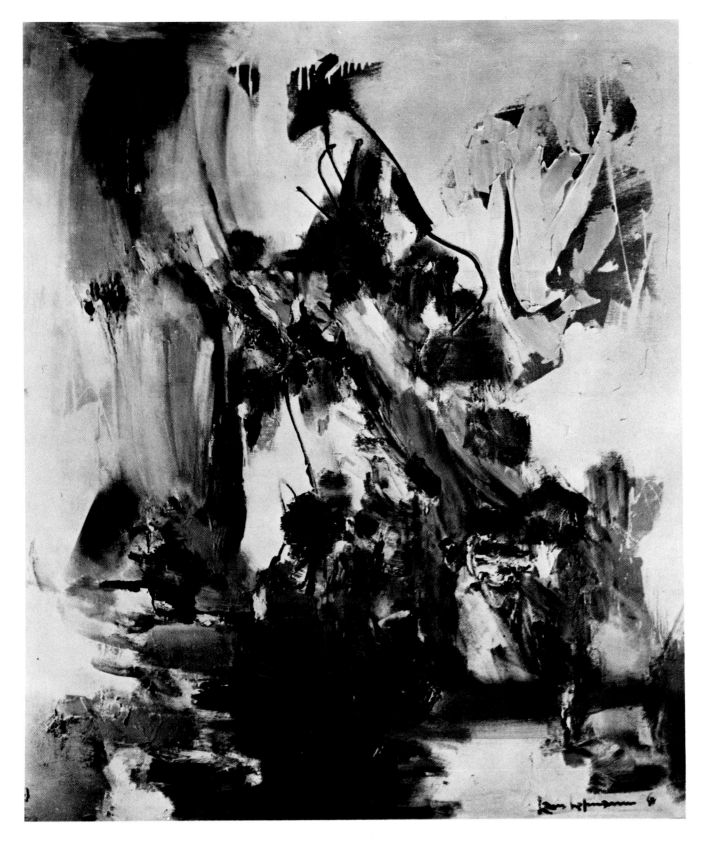

41

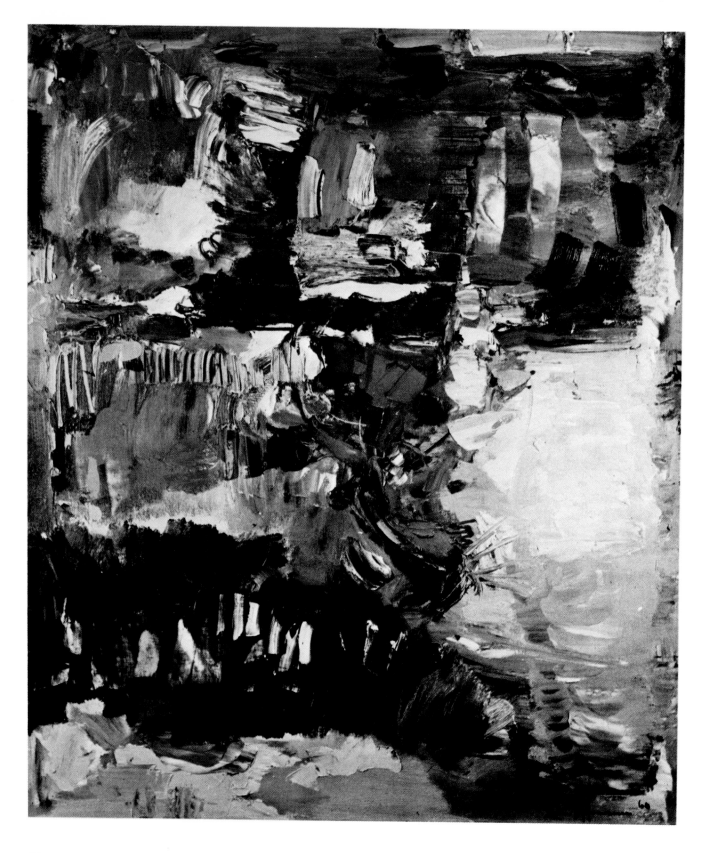

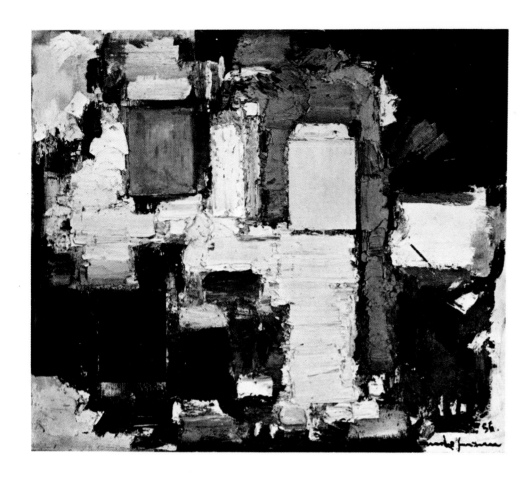

Left: **Yellow Burst.** 1956.
Oil on canvas, 52¼ x 60¼".
Collection Mr. and Mrs.
Samuel M. Kootz, New York

Opposite page: **In the Wake
of the Hurricane.** 1960.
Oil on canvas, 72¼ x 60".
Owned by the artist

sonorous — a profound and elastic expansion of the tension and rhythm of color, plane, brush, and line within the picture and across its surface. "The interplay of this multitude of motion produces a combined two- or three-dimensional rhythm with an ambiguous interpretation of its plastic fixations." Unlike Renaissance space, in which each detail is mechanically plotted to rest at a simple fixed position in depth, plastic creation (as one can see easily in certain of Cézanne's landscapes) can give an element a dual, or even multiple, location in depth, and thereby movement and rhythm as well.

Opposition is as operative in Hofmann's work stream as it is in his individual pictures, so that he has been criticized for painting in too great a diversity of manners. Indeed, few painters have tried to embrace such contradictory extremes. Yet this variety is anything but random, and the manners are not without common philosophical ground. The pictures constructed from scrupulously adjusted rectangles of color, such as **Combinable Wall** (pages 28, 29) and **Cathedral** (page 31), lie at what could be called the Apollonian pole of Hofmann's art; at the opposite extreme are such dynamically brushed pictures as **The Prey** (page 37) and **Tormented Bull** (page 9), — emotional explosions of atavistic ferocity — or **Summer Night's Bliss** (color pl. 5) — a romantic abandonment to lyricism. The ways in which pigment is applied contribute enormously to the various moods as well as to the enlivenment of surfaces, which are never without marks of Hofmann's tools and gestures. Even the compositions of parallel rectangles are varied in their brushing — in some the paint is troweled like a roughly plastered wall. In other works, such as the great

Left and right:
Details of **Lava** (color plate 4), 1960.
See also cover.

Lava (color pl. 7; details pages 44, 45, and cover), the treatment shifts to an organically boiling and breathing impasto, a maelstrom into which a hundred or more tubes of paint can be squeezed. Yet Hofmann can also construct a megalithic monument on a seven-foot canvas, as in **Agrigento** (page 20), with a single wash of diluted pigment.

The various modes are also combined: some of the finest canvases are those in which great colored planes stand like temples in a luxuriant landscape of blooming and sun-filled pigmentation. No other painter is able to contain such dichotomies within an embracing unity. In another group, such as **Liebesbaum** (page 40), **Blue Rhapsody** (page 36) or **In the Wake of the Hurricane** (page 42), Hofmann's architectural predisposition almost totally relinquishes its control, to leave a quivering universe of color, motion, and mood.

Like frozen lava, Hofmann's incrusted surfaces are a sculptural record of his super-human expressive force — energy transformed into matter. The crested waves of pigment harden into edges so keen that they can literally draw blood, with points of spray as sharp as needles. But however explosive Hofmann's paintings become, they are never only centrifugal; their expansion is always subject to contraction, in a systole and diastole which leads, as Hofmann writes, to "monumentality and universality," and to a final accumulation of energies producing an over-all rhythm in which "the message of the work finds its aesthetic perfection as an entirely independent spiritual reality."

color

It may seem to be an enormous oversight to have omitted Hofmann's views on color up to this point, for it is color which to him determines form rather than the opposite. Indeed, painting is no more than "forming with color."[9] The postponement can be justified, however, not only because it is possible to create plastically without color, but because, in theory if not in practice, he treats formal relationships and color relationships as independent systems which the painter must coördinate. Each with its own inherent laws and characteristics, form and color must operate in an interplay which "leads to a pictorial consonance comparable to harmony and counterpoint in music...."

Hofmann differentiates sharply between "pure painting," in which color is given full autonomy and expression, and its antithesis "tonal painting," in which "color is degraded to a mere black-and-white function." Tonal painting often accompanies the use of linear perspective to achieve recession, as in the art of the Renaissance. When used for its intrinsic qualities in "pure painting," color is a form of light: "In nature, light creates the color; in the picture, color creates light." Yet to be "pure," colors need not approach the hues of the rainbow; any shade or tint, however grayed or inter-mixed, can be used purely, for each combination "emanates a very characteristic light — no substitute is possible."

Continuity of color development is achieved through successful, successive development of the color scales. These are comparable to the tone scales in music. They can be played in major or in minor. Each color scale follows again a rhythm entirely its own. The rhythmic development of the red scale differs from that of the blue scale or the yellow scale, etc. The development of the color scales spreads over the whole picture surface, and its orientation, in relation to the picture surface, is of utmost importance.

As is the case with formal tensions, the color and light unity of a work depend not only on the characteristic emanations of given areas of color, but upon the relation of these units to each other. Any individual color quality can also be varied by the physical texture of the pigment, "an additional light-producing factor capable of altering the luminosity of the colors."

Colors are separated by "intervals" in Hofmann's paintings, just as planes or other forms are separated by "tensions"; indeed, the words "tension" and "interval" are all but synonymous in his vocabulary.

Intervals are tensional variations, the degree of which characterizes a given relation. In a relation, two colors engage each other in a simultaneously accelerated intensification or diminution. None is the winner and none the loser. They are united to carry a meaning through their interaction. The divergency in both makes the tensional difference of the interval. . . .

The formal development of the work and the color development are performed simultaneously. The color development leads thereby from one color scale to the other. Since every color can be shaded with any other color, an unlimited variation of shading within every color scale is possible. Although a red can be, in itself, bluish, greenish, yellowish, brownish, etc., its actual color-emanation in the pictorial tonality will be the conditioned result of its relationship to all the other colors.

Any color shade within one color scale can become, at any moment, the bridge to any other color scale. This leads to an interwoven communion of the color scales over the entire picture surface.

Whereas in tonal painting neighborhood relations are achieved through dark-and-light transitions, in pure painting the rhythmic interweaving of the color scales brings the color into an "open" neighborhood relationship in which colors are compositionally in accordance with a color development upon which their formal grouping ultimately depends. The colors meet now in neighborly relation in the sense of tensional difference — that is to say, in the sense of simultaneous contrast. The finest difference in color shades can achieve powerful contrasts. Although tonal development may lead to an over-all pictorial harmony, it sacrifices simultaneous contrast, which is the predominant quality of pure painting.

Functioning in interaction with plane, line, impasto, and other aspects of formal structure, color greatly influences the effect of volume and depth: "The most pronounced depth-suggestion is then enriched, in the painterly process, by greatest voluminosity, which generally requires a deeper shading of color with a consequent diminution of luminosity." Generally, if not in every case, "lesser formal depth suggestion demands diminution of volume and intensification of luminosity."

As a work develops Hofmann begins to group his pictorial elements in nuclei, so that the composition is finally dominated by a few related "complexes" of color:

In a complex, a few, a greater number, or a multitude of colors (or color shades) meet. . . . In spite of a multiplicity of shaded differences, their synthesis presents itself as one color complex contrasted with another, and with all the other color complexes within the pictorial totality. . . ."

A color complex presents volume in a multitude of color vibrations. In pure painting we deal always with created color in the sense that jewels create color. A ruby is red, an emerald is green, a sapphire is blue, a topaz is yellow, etc., and they retain their color identity in every change of normal light condition. But when we analyze the red or the yellow or the blue in these precious stones, we find that we deal not with a simple red, yellow, green or blue, but with a multitude of prismatically differentiated colors which, in their gathered intensity, create in us the idea of the ruby red, the sapphire blue, the topaz yellow, the emerald green, etc. In pure painting the interplay of the color leads to the creation of the intended effect of a blue, a red or a yellow, and the total harmony among them emanates the aspired creative intention. This concept differs from another concept by which great simplified decorative areas are desired. This concerns the art of elimination. In the decorative domain, it must be understood that any color mixture becomes a pure color when it is thoroughly flat-mixed, so that it carries only one light meaning.

Of all the means at the painter's disposal color is the most immaterial, the most subject to change through counteraction, and the most mysterious. More than any other means, therefore, its cumulative effect is dependent on relations.

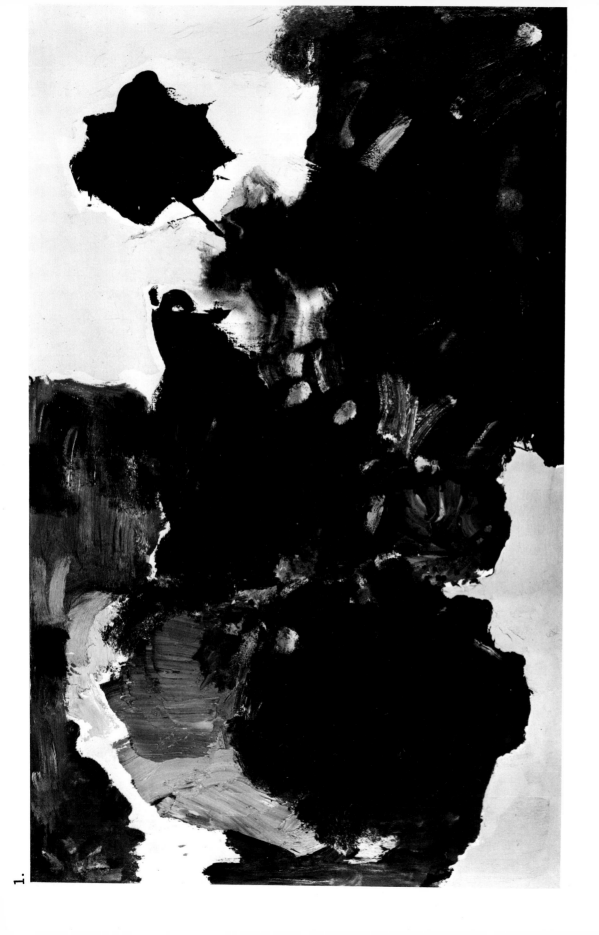

Towering Clouds. 1958. Oil on canvas, 50¼ x 84".
Collection Mr. and Mrs. Samuel M. Kootz, New York

1.

2.

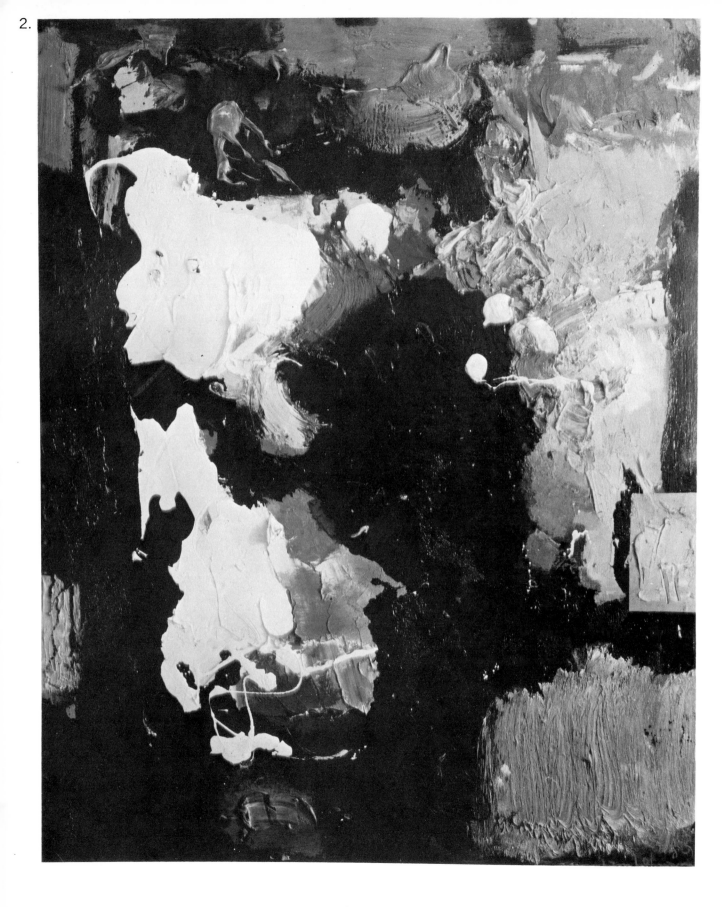

3.

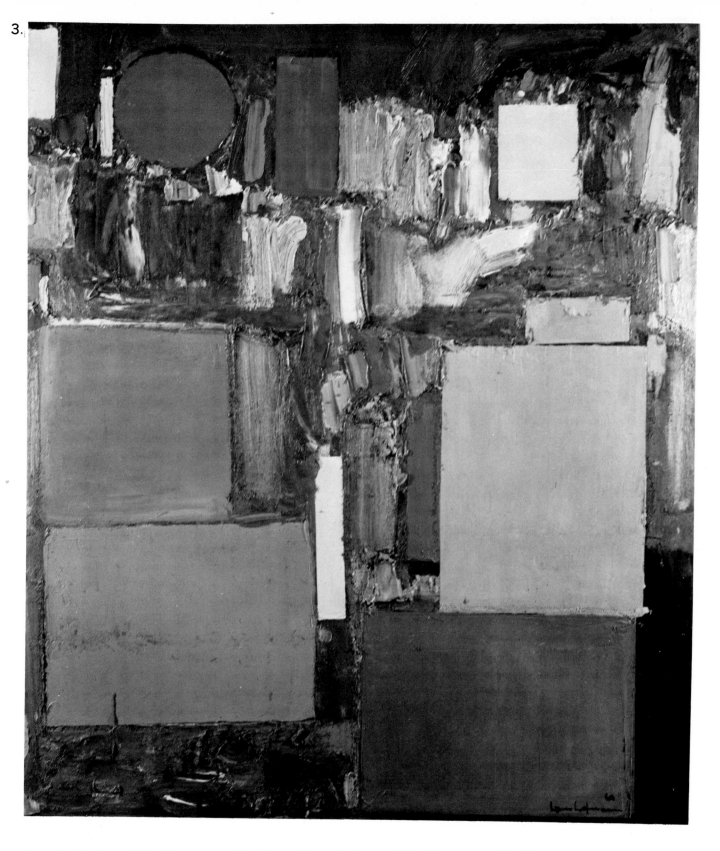

Opposite: **Conjurer.** 1959. Oil on canvas, 60 x 45".
Bavarian State Painting Collection, Munich

Above: **Pre-Dawn.** 1960. Oil on canvas, 72 x 60".
Collection Prentis C. Hale, San Francisco

4.

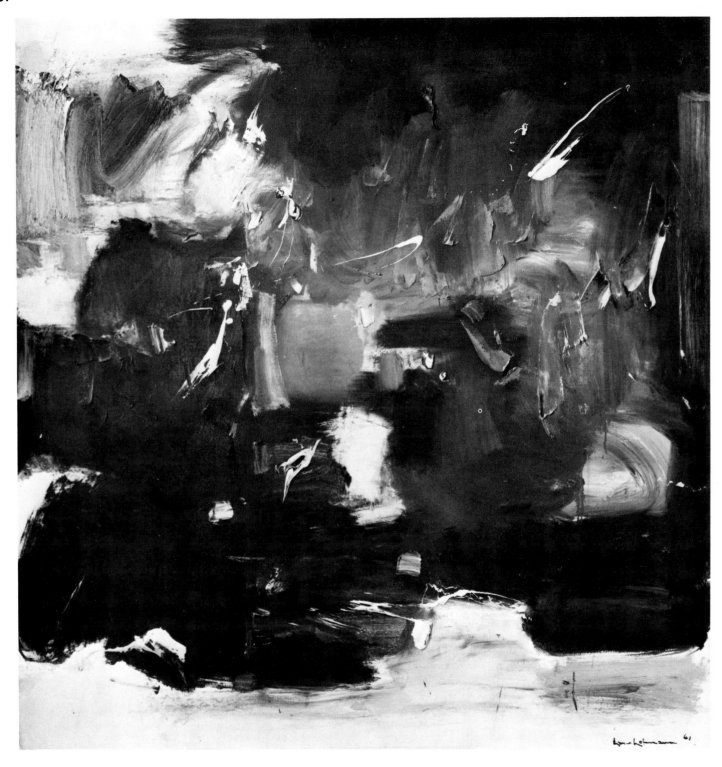

Opposite: **Lava.** 1960. Oil on canvas, 72 x 60".
Collection Mr. and Mrs. Paul Tishman, New York

Above: **Summer Night's Bliss.** 1961. Oil on canvas,
83⅞ x 78". The Baltimore Museum of Art

6.

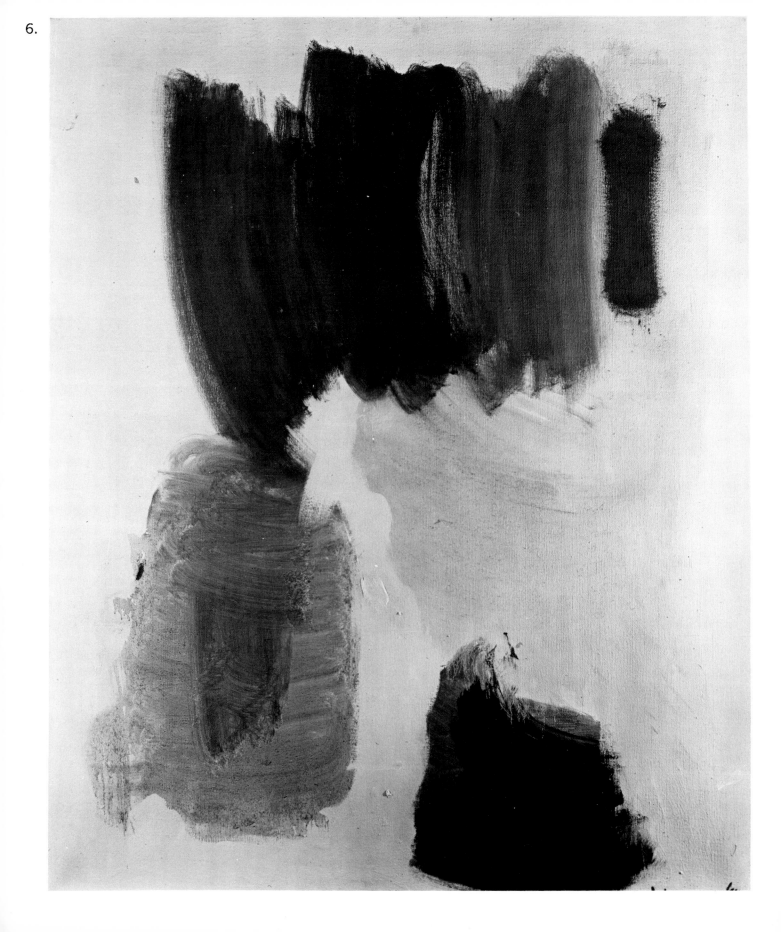

7.

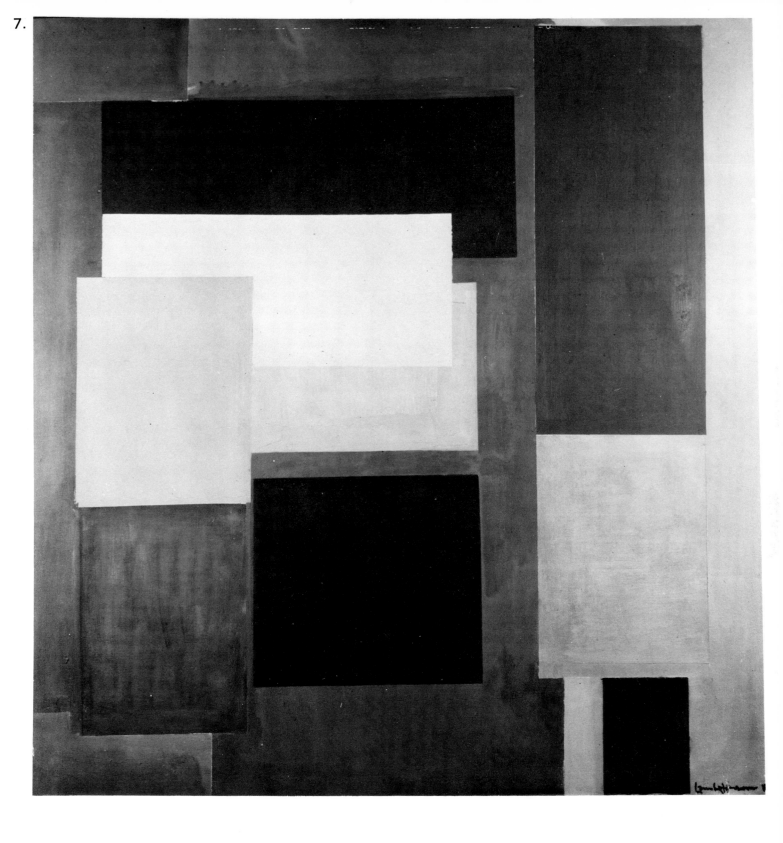

Opposite: **Delirious Pink.** 1961. Oil on canvas,
60 x 48". Owned by the artist

Above: **Lumen Naturale.** 1962. Oil on canvas,
84 x 78". Owned by the artist

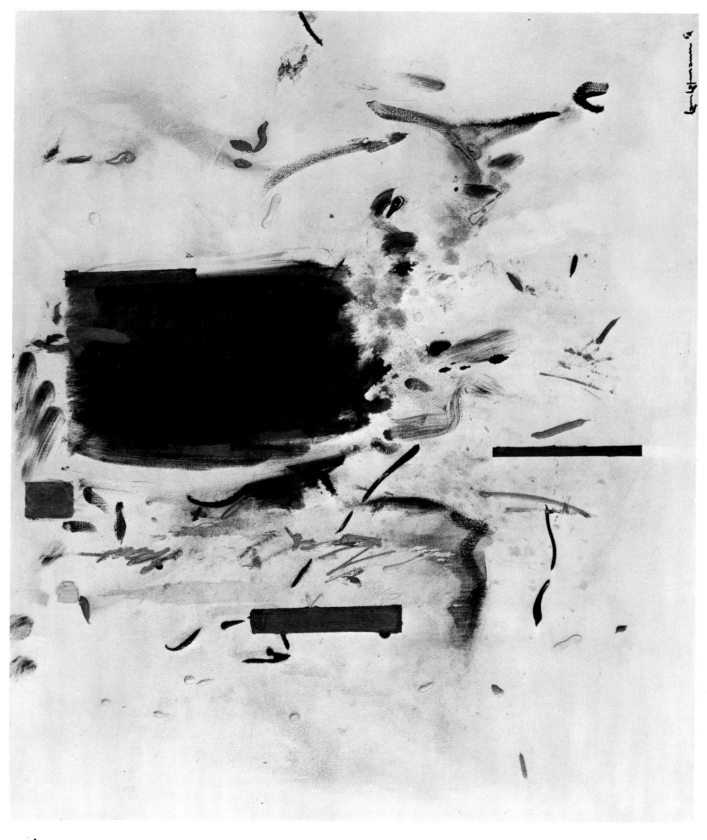

8.

Whisper of the South Wind. 1962. Oil on canvas,
60 x 70″. Owned by the artist

relations

A color interval, in Hofmann's metaphysics, "is analogous to a thought-fragment in the creative process." The relation between elements, whatever they may be, is always more significant than the elements themselves: "Any isolated thing never can surpass its own meaning." The more highly developed the art, the more its raw components are absorbed and transformed by their juxtaposition. As a primary exercise in drawing, Hofmann demonstrates that a given line is "short" or "long" only by comparison with another line placed near it, and that both derive their effect of movement and depth from their relation to each other and to the four outlines of the picture surface. In sculpture "a head is not round or square in itself, it is only so in relation to another basic form which is less round or square. Only through relationship and opposition can 'form' be defined in its relative and characteristic proportion."

Pictorial relationships have many origins: the placement of elements; varying degrees and qualities of volume, depth, flatness, and pigmentation; effects of speed, improvisation or deliberateness — the list could be endless. In using color, the most protean of means, multitudes of juxtapositions involving "interval" are possible.

In a relation, two physical carriers always produce a nonphysical higher third as the aesthetic affirmation of the relation. Relations operate on different levels (experienced as tensions, or contrasts and opposites) within the inherent laws of any given medium of expression. Thereby, a new reality is produced in the aesthetic form of intervals on which plasticity and any other form of creation is based. Intervals are the expression of emotional differentiations in regard to intensity, to force and timing, to emphasis and suppression and so forth. . . . The equivalent of one relation can be related again with the equivalent of another relation. We deal then with 'relations under relations' as the highest form of aesthetic extension.

In works on the scale of those in the present selection, Hofmann usually aims at symphonic, or "monumental," art. "Monumentality," he writes, "is an affair of relativity. The truly monumental can only come about by means of the most exact and refined relation between parts. Since each thing carries both a meaning of its own and an associated meaning in relation to something else, its essential value is relative. We speak of the mood we experience when looking at a landscape. This mood results from the relation of certain things rather than from their separate actualities. This is because objects do not in themselves possess the total effect they give when interrelated." But monumentality, or even an effect of "bigness" in a work of art, is not necessarily a function of physical size: "The width of a line may present the idea of infinity. An epigram may contain a world. In the same way, a small picture format may be much more living, much more leavening, stirring, awakening than square yards of wall space."

Traditionally, a painting used to begin as a rough sketch of the main lines or areas of a preconceived image, and this is still often the case; but with Hofmann, painting is from the first stroke a continuing establishment and re-establishment of live relationships. As it progresses, the work moves toward a more perfect integration of all its parts — toward a relational unity. "Pictorial homogeneity of the composition (plastic unity) is developed by lawfully governed inner necessities. These inner necessities are dictated by the nature of the medium, and from the orchestration of its inner qualities arise formal movement, tensions, intervals, complementary relations, contrasts, and complexes." At every phase the painting should be a work of art — i.e., its elements should be in equilibrium — rather than a fragment, and the painter must guard against being confused by his own creation. "We can lose ourselves in the multiplicity of lines, if through them we lose our sense of planes, and we can lose our sense of planes if it is

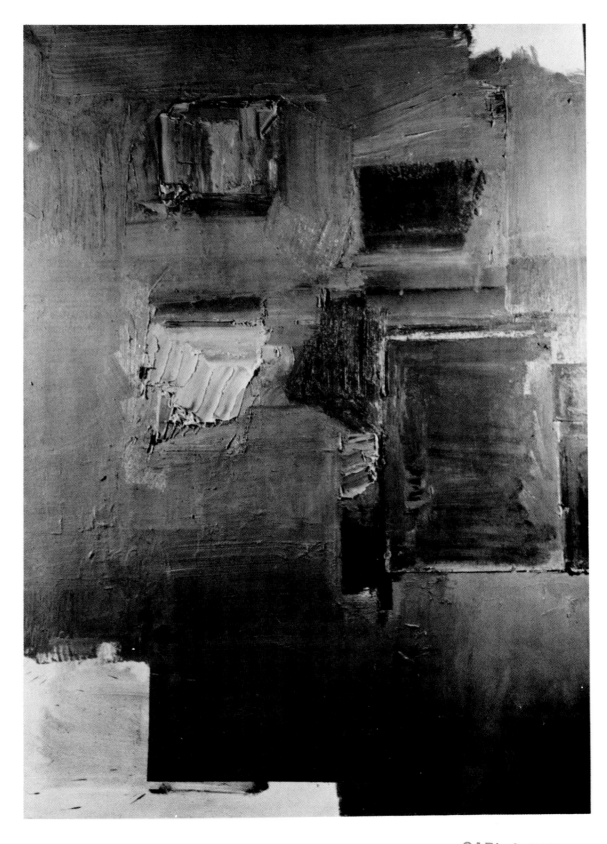

Mecca. 1961.
Oil on canvas, 84 x 60".
Collection Mrs. Albert H.
Newman, Chicago

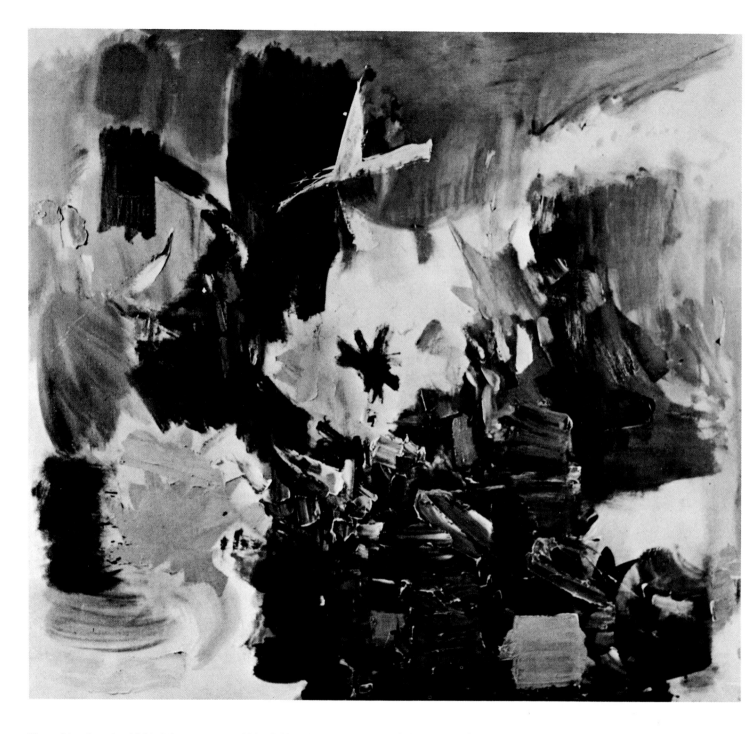

Moonshine Sonata. 1961. Oil on canvas, 78⅛ x 84⅛″. Samuel M. Kootz Gallery, New York

not based on the conception of volume. . . . We can even lose ourselves in the multiplicities of volumes when the spiritual perception of line, plane, volume, and volume complexity is not based upon a conception of spatial unity."

Strong tensions and sharp breaks between units are typical of Hofmann's paintings. Only in the most "painterly" works are the intervals muffled by transitions or complications. As a picture progresses, they are clarified and simplified. "Every creative work of art requires elimination and simplification. Simplification results from a realization of what is essential." The number of color and form "complexes" in a picture usually is reduced to a very few. Repeatedly Hofmann calls attention to the precise adjustments which constitute completion. Even the signature is an element of major importance. Its size and placement can be a key passage that finishes a work and establishes its scale, or it can harm it. The signature is often placed, removed, and replaced several times, and it has been necessary to rework entire paintings after they were signed. In some cases it is omitted entirely. Hofmann draws a parallel between painting and atomic physics, in which the reaction which transforms matter into energy can occur only if proper components are brought together in absolutely correct amounts. Similarly, in a painting "the effects potentize themselves. What in the two-dimensional fixation of the appearance would perhaps only be the difference of a fraction of a millimeter" could make an infinite difference in the total effect.

When does the creative process come to a conclusion? "A work of art is finished from the point of view of the artist when feeling and perception have resulted in a spiritual synthesis"[10]; "a work is finished when all parts involved communicate themselves, so that they don't need me."[11] And when a painting is wholly successful it achieves "quality . . . the fruit of a sensitive and creative mind." Only a plastic artist can produce quality, a spiritual reality created by physical means.

art and metaphysical reality

Modern philosophy has been criticized for abandoning metaphysics for semantics. Among the best-known philosophers of this century A. N. Whitehead stands out by continuing the ancient quest for metaphysical truth. In an age of communication through the impalpable media of radio and television it is surprising to realize that men of intelligence deny — in their habits of thought if not by overt rebuttal — the reality of phenomena not subject to verification by touch, sight, or hearing. It has been the artists, both in their works and their writings, who have given the most convincing arguments for spiritual reality.

Hofmann makes a sharp distinction between physical reality, "apprehended by the senses," and spiritual reality "created emotionally and intellectually by the conscious or subconscious powers of the mind." This order of reality, termed "surreal" by Hofmann, is manifest in what he calls "the spiritual third," which enables the artist to "impregnate physical limitation from within."

The relative meaning of two physical facts in an emotionally controlled relation always creates the phenomenon of a third fact of a higher order, just as two musical sounds, heard simultaneously, create the phenomenon of a third, fourth, or fifth. The nature of this higher third is nonphysical. In a sense it is magic. Each such phenomenon always overshadows the material qualities and limited meaning of the basic factors from which it has sprung. For this reason art expresses the highest quality of the spirit when it is surreal in nature; or, in terms of the visual arts, when it is of a surreal plastic nature.

Considerations such as these, though they approach mysticism and cannot be fully explained, should not be pushed aside as poetic extravagance. They are irreducible

facts of creative experience, and intrinsic data concerning works of art. It is the mysterious, transubstantiated spiritual substance, Hofmann believes, that gives great art its permanence. "In the passage of time, the outward message of a work may lose its initial meaning; the communicative power of its emotive and vital substance, however, will stay alive as long as the work is in existence. The life-giving zeal in a work of art is deeply imbedded in its qualitative substance. The spirit in a work of art is synonymous with its quality. The **Real** in art never dies, because its nature is predominantly spiritual."

notes

1. Loran's statement is taken from the "Hofmann Students Dossier" (bibl. 91), in the Library of The Museum of Modern Art. It includes comments on Hofmann as a teacher by many of his former students.
2. This quotation from Hofmann, and the great majority of those used in this text, are drawn from his "Selected Writings on Art," assembled by the artist (bibl. 30). A copy can be found in the Museum Library. The selections have been taken mainly from bibl. 5, 7, and 18. Minor revisions, some by the artist and others, mainly in punctuation, by the author have been made in certain of these quotations.
3. Exhibition catalogue, Kootz Gallery, New York, Jan. 1960.
4. It is of interest to compare Mark Tobey's concept of pictorial means and processes with that of Hofmann. See my **Mark Tobey,** Museum of Modern Art, 1962, pp. 19-32 and 41-51.
5. Hofmann's use of the term "plastic" demands comment. In its limited denotation, it identifies any pliable material, such as molding clay or Plasticine, that will retain a shape given by manipulation. In German, "Plastiker" is a synonym for "Bildhauer," i.e., "sculptor."

 Used in a less physical sense the term "plastic" can refer to formative energy, as, "the 'plastic' force of nature; 'plastic' imagination." Hofmann uses the word in both senses, but opens it out to connote the insight, control, and creativeness that distinguish the product of an artist from that of a craftsman, illustrator, or decorator.
6. E. de Kooning, "Hans Hofmann paints a Picture," **Art News,** V. 48, no. 10, Feb. 1950, p. 40.
7. Hofmann notes that this is only "relatively" true, "because every flat surface is colored in some way. When the surface is absolutely white, it carries the meaning of 100% white and not one iota more or less; it is 100% volume expressed in pure white. And because of its 100% volume, the surface is absolutely flat but not empty.
8. de Kooning, **op. cit.,** p. 38.
9. Most of the quotations from Hofmann in this selection are taken from **The Color Problem in Pure Painting** (bibl. 18.)
10. See de Kooning, **op. cit.,** p. 59.
11 In **Modern Artists in America,** New York, Wittenborn Shultz, Inc. [1951], p. 12.

Opposite: **Memoria in Aeterne** — Dedicated to Arthur Carles, Arshile Gorky, Jackson Pollock, Bradley Walker Tomlin, Franz Kline. 1962. Oil on canvas, 84 x 72⅛". Samuel M. Kootz Gallery, New York

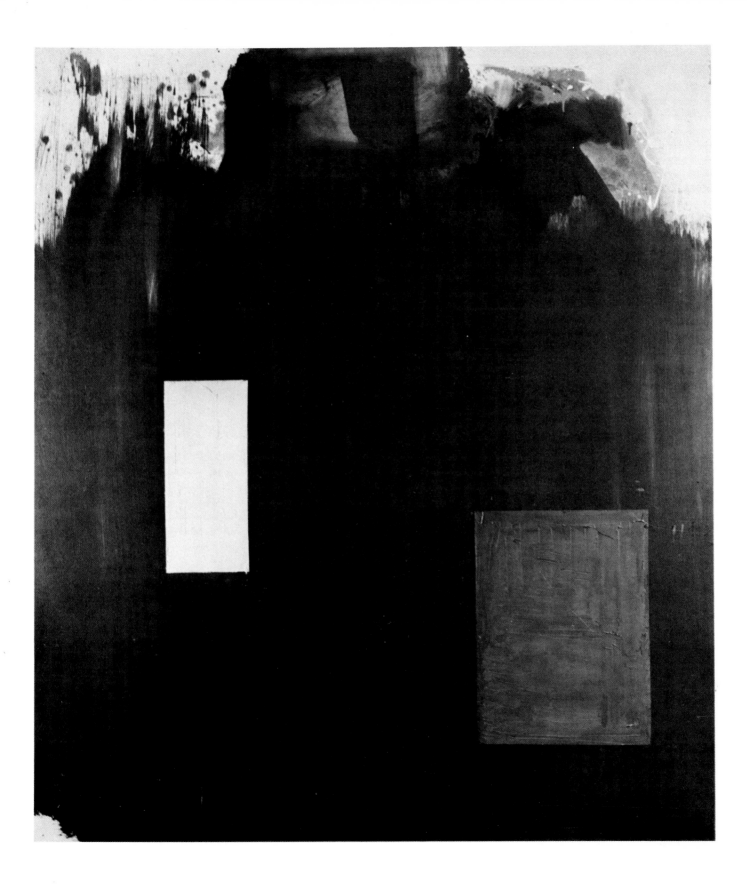

SCHULE FÜR BILDENDE KUNST
HANS HOFMANN
MÜNCHEN / GEORGENSTRASSE 40 / TEL. 34259

Die Kunst besteht nicht in der gegenständlich objektivierenden Nachbildung der Wirklichkeit. Die vollendetste gegenständliche Nachbildung der Wirklichkeit ist als Form tot, Fotografie oder Panoptikum, wenn ihr die Impulse der künstlerischen Gestaltung fehlen. Die Form im Sinne der Kunst erhält ihre Impulse zwar durch die Natur; sie ist jedoch nicht an die gegenständliche Wirklichkeit gebunden, sondern vielmehr an das künstlerische Erlebnis aus der gegenständlichen Wirklichkeit und mit diesem an die Beherrschung der geistigen Mittel der bildenden Kunst, durch die das künstlerische Erlebnis erst und mit ihm die Wirklichkeit im Bilde zum Ausdruck kommt. Ausdrucksvolle Gestaltung ist somit geistige Übersetzung des Seelischen in Form, durch Verschmelzung des Seelischen mit dem künstlerischen Ausdrucksmittel zu einer formalen und geistigen Einheit, in der sich der Gestaltungsdrang durch den gesamten Sinnes- und Gefühlskomplex und durch die lebendige Beherrschung der geistigen Mittel bis zur Steigerung in die Intuition auswirkt. Eine Nachbildung der gegenständlichen Wirklichkeit ist also keine Gestaltung, sondern Dilettantismus, oder als Produkt einer reinen Verstandesleistung, eine wissenschaftliche Fixierung. Das Kunstwerk ist ein in sich geschlossenes geistiges und formales Ganzes, in welchem es, trotz der Vielheit gezeigter Objekte, durch die geistigen Beziehungen seines Aufbaues keine Teile gibt. Jedes gegenständlich einzeln Wirkende fällt daher aus dem geistigen Zusammenhang und ist somit Flick-, nicht Stückwerk, und als solches wund damit das Ganze, geistig minderwertig. – Der Künstler beherrsche deshalb die geistigen Mittel der bildenden Kunst, diese sind die Form und das Fundamente der bildenden Kunst und gestalte sein geistiges Bild von der Natur, d. i. sein Erlebnis, vor der Natur oder frei. Durch diese Erkenntnisse sind die Aufgaben der Lernjahre klar vorgezeichnet und damit auch die weitere Entwickelung des Künstlers, die sich dann unabhängig von Schulen und Richtungen, aus der Persönlichkeit heraus, vollziehen muß.

DAS LEHRPROGRAMM DER SCHULE FÜR DIE EINZELNEN FÄCHER IST UMSTEHEND ENTWICKELT.

UNTERRICHTS- STUNDEN	VORMITTAG	9 – 12	AKT- UND KOPFSTUDIEN
	NACHMITTAG	2 – 4	KOPF- UND KOSTÜMSTUDIEN
	ABEND-AKT	5 – 7	MIT EINZELMODELL U. GRUPPEN

LEHRFÄCHER: Die 2 und 3 dimensionale Beherrschung der Form: Silhouette, Fläche und Volumen, Bewegung und Gegenbewegung, die 2 und 3 dimensionale Rythmik; Dynamik der Massen; formale Spannung und Funktion: das Raumproblem, Raumspannungen und Raumplastik, die Funktionen im Raum; die Gestaltung der lebendigen und vergeistigten Form in ihrer Beziehung zum formalen und geistigen Ganzen, d. i. zur Komposition.

ZEICHNEN VON DER NATUR

MALEN V. DER NATUR U. FREI: Die 2 dimensionale Beherrschung der Fläche, Valeure und Kontraste; das Equilibrar: die 3 dimensionale Auswirkung, Qualität und Transparenz. Die reine Farbe, Abstraktion, Übersetzung; Intervalle und Klänge, Simultanität und Gesetzmäßigkeit, die entmaterialisierte, vergeistigte Farbe.

KOMPOSITION: In 2 u. 3 dimensionale-konzentrischer Auswirkung. (frei u. v. d. Natur).

STATUTEN: Die Statuten der Schule werden in der Schule durch den Obmann bei der Anmeldung ausgehändigt.

HONORAR: Das Honorar wird monatlich berechnet und wird durch Anschlag in der Schule bekanntgegeben. Das Honorar ist im Voraus zu entrichten.

PRIVAT-KORREKTUR: Einzelkorrektur oder in monatl. Berechnung je nach Vereinbarung.

ANMELDUNG U. ABMELDUNG: Die Anmeldung verpflichtet zum Besuche der Schule von mindestens einen Monat. Der Eintritt in die Schule ist jederzeit möglich. Die Kündigungsfrist beträgt 4 Wochen. (Näheres durch die Statuten).

ZUR BESONDEREN BEACHTUNG FÜR AUSLÄNDISCHE STUDIERENDE: Ausländische Studierende erhalten die Aufenthaltsbewilligung durch den Besuch der Schule. Die Aufenthaltsbewilligung erteilt das Fremdenamt der Polizeidirektion München, Ettstr. 4 Zimmer 141. Dieselbe ist dort persönlich mit einer Bescheinigung der Schule über die erfolgte Anmeldung u. von auswärts durch die Vermittelung der Schule nachzusuchen. Beim Übertritt eines ausländischen Schülers von einer Schule in die andere Schule müssen die beiden Schulen rechtzeitig benachrichtigt werden, damit die Schulen die vorschriftsmäßigen Ab- u. Neuanmeldungen beim Fremdenamte der Polizeidirektion gleichzeitig vornehmen können.

SCHOOL OF FINE ARTS
HANS HOFMANN
MUNICH/GEORGENSTRASSE 40/TEL. 34259

Art does not consist in the objectivized imitation of reality. Without the creative impulse of the artist, even the most perfect imitation of reality is a lifeless form, a photograph, a panopticon. It is true that, in the artistic sense, form receives its impulse from nature, but it is nevertheless not bound to objective reality; rather it depends to a much greater extent on the **artistic experience** evoked by objective reality and the artist's command of the spiritual means of the fine arts, through which this artistic experience is transformed by him into reality in painting. Creative expression is thus the spiritual translation of inner concepts into form, resulting from the fusion of these intuitions with artistic means of expression in a unity of spirit and form, brought about by intuition, which in turn results from the functioning of the entire thought and feeling complex accompanied by vigorous control of the spiritual means. Imitation of objective reality is therefore not creation but dilettantism, or else a purely intellectual performance, scientific and sterile. A work of art is, in spirit and in form, a self-contained whole, whose spiritual and structural relationships permit no individual parts, despite the multiplicity of depicted objects. Every independent element works against the spiritual context, and makes for patchwork, reducing the total spiritual value. The artist must therefore learn the spiritual media of the fine arts, which constitute its form and fundamentals. The artist must create his particular view of nature, i.e., his own experience, be it from nature or independent of it. Through these realizations the assignments of the scholastic years will be clearly understood, insuring the further development of the artist, who must then detach himself entirely from schools and directions and evolve a personality of his own.

Class Hours:	Mornings	9-12	Life and Head Studies
	Afternoons	2-4	Head and Costume Studies
	Evenings (Life Classes)	5-7	Single Model and Groups

Courses:

Drawing: from Nature — Mastery of 2 and 3 dimensional form, silhouette, planes and volume, movement and counter-movement, 2 and 3 dimensional rhythmics, dynamics of mass, formal tension and function: the problem of space, spatial tension and spatial mass, function in space, the creation of vital aesthetic form in relation to the form and spirit of the whole — i.e., composition.

Painting: from Nature and free — Mastery of 2 dimensional surfaces, color values and contrasts, equilibrium, 3 dimensional operations, quality and transparency, pure color, abstraction, transposition, intervals and accentuation, simultaneity and formulation, dematerialized, spiritualized color.

Composition: In 2 and 3 dimensional concentric operation (free and from Nature).

Regulations: The regulations will be handed to applicants by the Chairman of the school at the time of registration.

Fees: Fees are billed monthly, and notices concerning them will be posted in the school. Fees are payable in advance.

Private Criticism: Single criticism, or on a monthly basis, by agreement.

Requirements for Entrance and for Leaving: Applications for entrance are accepted for no less than one month's attendance at the school. Entrance is possible at any time.

Those intending to leave must give 4 weeks' notice. (Details in Regulations.)

Special Notice to Foreign Students

Attendance at the school entitles foreign students to a residence permit. These are issued by the Foreign Office of the Police Department, Ettstrasse 4, Room 141. The student must apply in person, bringing with him a certificate from the school testifying to his acceptance for entrance in the school as a foreign student, and requesting the permit through the intervention of the school. A foreign student transferring from one school to another must notify both schools at the proper time, so that the required written notices may be able to reach the Foreign Office of the Police Department at the same time.

chronology and exhibitions

One-man shows are listed in bold face type

1880 March 21: Hans Hofmann is born in Weissenburg, Bavaria, Germany.

1886 Father becomes a government official and family moves to Munich. Attends public schools and later Gymnasium; excells in science and mathematics. Also studies music, playing the violin, piano and organ. Begins drawing. Frequent visits to maternal grandparents' grain farm encourages his love of nature.

1896- Leaves home to be on his own; with father's
1898 help gets position as assistant to the Director of Public Works of the State of Bavaria. This enables him to develop his technical knowledge of mechanics, resulting in the invention of an electromagnetic comptometer. Financial assistance from his father encourages further scientific investigation, but instead he uses money to enroll at art school. Studies with various teachers, finally with Willi Schwarz, who has been in Paris, and introduces him to impressionism. At this time the Sezession group is active in Munich.

1900 Meets Maria (Miz) Wolfegg.

1903 Through Willi Schwarz meets nephew of Berlin collector, Phillip Freudenberg, who becomes his patron and sends him to Paris, helping to support him there until 1914. Summers are often spent in Germany.

1904 Attends evening sketch class at the Ecole de la Grande Chaumière; Matisse also working there at the time. Takes an active part in the international art circle. Close friendship with Delaunay, during which he develops as a colorist. First meets Picasso and Braque and becomes acquainted with the cubist group. Paints still lifes, landscapes and figure pieces in cubist style. A number of these are sent to Phillip Freudenberg in Berlin, but they have since disappeared.

1909 Shows with Neue Sezession, Berlin.

1910 **Paul Cassirer's, Berlin** (first one-man show).

1914 Winter: Sister's illness brings him back to Munich; stays for the summer and is caught by the outbreak of the first World War. Kept out of the army by aftereffects of a lung condition. Assistance from his patron Freudenberg terminated by war. To earn his living decides to teach.

1915 Spring: Hans Hofmann School of Fine Arts opens at 40 Georgenstrasse, Munich. The school is a success from the start. (See Appendix, p. 56.)

1922- Takes students on summer trips: Tegern See,
1929 Bavaria, 1922; Ragusa, 1924; Capri, 1925-27; St. Tropez, 1928-29.

1923 Marries Miz Wolfegg after a long courtship.

Photograph of the artist, Provincetown, 1959.
Photograph by Marvin P. Lazarus.

1930 At the invitation of Worth Ryder, a professor of art who was among the many Americans who had studied with Hofmann, is invited to teach in the summer session at the University of California at Berkeley, where Ryder is Chairman of the Department of Art. Returns to Munich for the winter.

1931 Spring: Teaches at Chouinard School of Art, Los Angeles; summer session again at Berkeley.
August: **California Palace of the Legion of Honor, San Francisco.** (first exhibition in the U.S. — drawings).

1932 Because of a growing political hostility to intellectuals, and as advised by Mrs. Hofmann who remains in Germany, closes Munich school and settles permanently in the U.S. Spends winter teaching at Art Students League in New York.

1933 Summer: Guest-Instructor at Thurn School of Art, Gloucester, Mass.
Autumn: Opens a school on Madison Avenue, New York.

1934 Spring: Because his visa has expired, goes to Bermuda for a few months and returns with a permanent visa.
Summer: Teaches again at Thurn School, Gloucester.
October: **The Hans Hofmann School of Fine Arts opens at 137 East 57th Street, New York.**

1935 Summer: Opens his summer school at Provincetown, Mass. After a long period working only on drawings, starts to paint again.

1936 October: The Hofmann School moves to 52 West 9th Street where it remains until 1938 when it moves to its permanent location at 52 West 8th Street.

1939 August: Mrs. Hofmann comes to U.S. and joins her husband in Provincetown.

1940 His work progresses steadily toward abstraction.

1941 Becomes U. S. citizen.
March: **Isaac Delgado Museum of Art, New Orleans.**

1944 March 7-31: **Art of This Century, New York** (first exhibition in New York — abstract oils, gouaches, drawings — arranged by Peggy Guggenheim).
Nov. 3-25: **Arts Club of Chicago** (34 paintings, 1941-44).
Nov. 25-Dec. 30: Mortimer Brandt Gallery, New York, "Abstract and Surrealist Art in America" (arranged by Sidney Janis).

1945 April: **Howard Putzel's 67 Gallery, New York.**
Nov.: Whitney Museum of American Art, "Contemporary American Painting." (included in all subsequent Whitney Museum painting annuals).

1946 March 18-30: **Mortimer Brandt Gallery, New York** (arranged by Betty Parsons).
May: **American Contemporary Gallery, Hollywood, Calif.**

1947 Mar. 24-Apr. 12: **Betty Parsons Gallery, New York.**
Nov. 6-Jan. 11, 1948: Art Institute of Chicago, "Abstract and Surrealist American Art."
Nov. 23-Dec. 13: **Kootz Gallery, New York** (subsequent shows annually, except 1948 and 1956).
Dec.: **Pittsburgh Arts and Crafts Center and Abstract Group of Pittsburgh.**

1948 Jan. 2-Feb. 9: **Addison Gallery of American Art, Andover, Mass.** (A large retrospective exhibition. Publication by Addison Gallery of American Art of his book, **Search for the Real and Other Essays.**)

1949 Jan.: **Galerie Maeght, Paris** (arranged by Kootz Gallery). Trip to Paris; visits studios of Braque, Brancusi and Picasso.

1950 Feb. 26-Apr. 2: University of Illinois, Urbana, Ill., "Contemporary American Painting and Sculpture." Purchase Award, Krannert Art Museum, University of Illinois. (Hofmann was also included in this exhibition in 1948, and in all subsequent shows.)
Oct. 3-23: Kootz Gallery, New York, "The Muralist and the Modern Architect."

1951 Jan. 23-Mar. 25: The Museum of Modern Art, New York, "Abstract Painting and Sculpture in America."

1952 Feb. 2-Mar. 22: Wildenstein Gallery, New York, "70 American Paintings 1900-1952."
May 7-June 8: Art Institute of Chicago, "12th Annual Exhibition of The Society for Contemporary American Art, Chicago." Purchase Prize.
Oct. 16-Dec. 14: Carnegie Institute, Pittsburgh, "Pittsburgh International Exhibition of Contemporary Painting."
Dec.: Sidney Janis Gallery, New York, "American Vanguard Art for Paris" (to be shown later at Galerie de France, Paris).

1953 Feb.: Galerie de France, Paris, "Regard sur la peinture américaine" (arranged by Sidney Janis).
Apr. 27-May 20: **Kootz Gallery, New York** (first showing of landscapes created from 1936-1939).

1954 Jan. 4-23: Sidney Janis Gallery, New York, "Nine Americans."
Jan.: **Boris Mirski Gallery, Boston.**
Jan. 24-Feb. 28: The Pennsylvania Academy of the Fine Arts, Philadelphia, "149th Annual Exhibition of Painting and Sculpture," T. Henry Schiedt Memorial Prize.
Oct. 5-Nov. 21: **Baltimore Museum of Art.**

1955 May: **Bennington College, Bennington, Vermont** (small retrospective selected by Clement Greenberg).

1956 March: **The Art Alliance, Philadelphia** (retrospective).
Apr.-May: **Rutgers University, New Brunswick, New Jersey.**
Designs mosaic mural for lobby of William Kaufmann Building, 711 3rd Avenue, New York (William Lescaze, Architect).

1957 Apr. 24-June 16: **Whitney Museum of American Art, New York.** (retrospective exhibition organized in association with the Art Galleries of the University of California, Los Angeles; subsequently shown at the following participating institutions in this order: Des Moines Art Center; San Francisco Museum of Art; Art Galleries of the University of California, Los Angeles; Seattle Art Museum; Walker Art Center, Minneapolis; Munson-Williams-Proctor Institute, Utica; Baltimore Museum of Art).
June 3-20: Poindexter Gallery, New York, "The 30's — Painting in N. Y."

1958 Jan. 14-Mar. 16: Whitney Museum of American Art, New York, "Nature in Abstraction." With the close of his New York school in the spring and the Provincetown school on August 30, gives up teaching to devote full time to painting. Moves his studio to the school quarters at 52 West 8th Street.
Designs mosaic mural for exterior of The New York School of Printing, 349 West 49th Street (Kelly and Gruzen, Architects).
Dec. 15-Feb. 8, 1959: Carnegie Institute, Pittsburgh, "Pittsburgh Bicentennial Interna-

tional Exhibition of Contemporary Painting and Sculpture."

1959 Jan.: Kootz Gallery, New York, Jan. 6-17, **"Paintings of 1958"**;
Jan. 20-31, **"Early Paintings"** (selected by Clement Greenberg).
July 11-Oct. 11: Museum Fridericianum, Kassel, Germany, "Documenta II."
Dec. 2-Jan. 31, 1960: Art Institute of Chicago, "63rd Annual American Exhibition." Flora Mayer Witkowsky Prize of $1,500.

1960 June-Oct.: XXX Biennale, Venice. U.S. Representation, with Philip Guston, Franz Kline and Theodore Roszac.
Sept.: Museo Nacional de Arte Moderno, Palacio de las Bellas Artes, Mexico City. II Bienal Interamericana. Honorable Mention.

1961 Jan. 4-Feb. 12: Art Institute of Chicago "64th Annual American Exhibition" Ada S. Garrett Prize.
Oct.-Dec.: Solomon R. Guggenheim Museum, New York, "American Abstract-Expressionists and Imagists."

1962 March: **Fränkische Galerie am Marientor, Nuremberg** (large retrospective exhibition, subsequently shown at Kölnischer Kunstverein, Cologne; Kongresshalle, Berlin).
Neuen Galerie im Kunstlerhaus, Rolf Becker, Munich (oils on paper, 1961-1962).

1963 Jan. 11-Feb. 10: Art Institute of Chicago, "66th Annual American Exhibition." Mr. and Mrs. Frank G. Logan Art Institute Medal and Prize of $2,000.
Feb. 1-24: **Santa Barbara Museum of Art.**
April 19: Death of Mrs. Hofmann, New York.
April 23-May 18: La Galerie Anderson-Mayer, Paris (oils on paper).
May 6-27: International House, Denver, Colo., "Hans Hofmann and His Students" (an exhibition now being circulated by The Museum of Modern Art, New York, in the U.S. and Canada, 1963-64).

Hans Hofmann in his studio, Provincetown, 1959. Photograph by Marvin P. Lazarus.

selected bibliography

by Inga Forslund

Texts by Hofmann (arranged chronologically)

1 Art in America. ART DIGEST v.4 no.19:27 Aug. 1930.
2 Painting and culture (as communicated to Glenn Wessels). FORTNIGHTLY (Campbell, Cal.) v.1 no.1:5-7 Sept.11, 1931.
3 On the aims of art. Translated by Ernst Stolz and Glenn Wessels. FORTNIGHTLY (Campbell, Cal.) v.1 no.13:7-11 Feb.26, 1932.
4 [Statement.] IN Hans Hofmann. [Exhibition announcement.] New York, Art of This Century. March 1944.
5 Search for the real and other essays. Andover, Mass., Addison Gallery of American Art, c1948. p.46-78.
 A monograph based on an exhibition, covering a half century of the art of Hans Hofmann, held at the Addison Gallery, Jan.2-Feb.22, 1948. Edited by Sarah T. Weeks and Bartlett H. Hayes, Jr. — Introduction by Bartlett H. Hayes, Jr., p.7-16. — Table of exhibitions p.16. — Illustrated introduction p.17-45. — The search for the real in the visual arts p.46-54. — Sculpture p.55-59. — Painting and culture p.60-64. — Excerpts from the teaching of Hans Hofmann — adapted from the essays On the aims of art and Plastic creation p.65-74. — Terms p.76-78. — Appendix: Visual catalogue of the retrospective exhibit of Hans Hofmann at the Addison Gallery, 1948, p.80-90.—Color notes p.91.
 Reviewed by Gyorgy Kepes in MAGAZINE OF ART v.45 no.3:136-137 Mar.1952.
6 [Statement.] IN Recent paintings by Hans Hofmann. [Exhibition announcement.] New York, Kootz Gallery, Nov.15-Dec.5, 1949. p.[2].
7 Plastic creation. Translated from the German. THE LEAGUE v.22 no.3:3-6 incl. ill. Winter 1950.
 Reprint of essay, written for the League, which first appeared in the issue of the Winter of 1932-33.
8 Homage to A.H. Maurer, IN Hartley-Maurer. [Exhibition catalogue.] New York, Bertha Schaefer Gallery, Nov.13-Dec.2, 1950.
9 [Statement.] IN Contemporary American painting. Urbana, University of Illinois, Mar.4-Apr.15, 1951. p.187-188.
10 Space pictorially realized through the intrinsic faculty of the colors to express volume. IN Hans Hofmann. [Exhibition catalogue.] New York, Kootz Gallery, Nov.13-Dec.1, 1951. p.[4].
11 [Statement.] IN Contemporary American painting. Urbana, University of Il'inois, Mar.2-Apr. 13, 1952. p.199-200.
12 Statement. IN Hans Hofmann. [Exhibition catalogue.] New York, Kootz Gallery, Oct.28-Nov. 22, 1952. p.[4].
13 [Statement.] IN Contemporary American painting and sculpture. Urbana, University of Illinois, Mar.1-Apr.12, 1953. p.189-190.
14 The mystery of creative relations. NEW VENTURES July 1953, p.22-23.
15 The resurrection of the plastic arts. NEW VENTURES July 1953, p.20-22.
 Reprinted in catalogue of Hofmann exhibition at Kootz Gallery, New York, Nov.15-Dec.11, 1954. p.[2-3].
16 [Statement.] IN Contemporary American painting and sculpture. Urbana, University of Illinois, Feb.27-Apr.3, 1955. p.207-208.
17 [Hofmann explains his paintings.] BENNINGTON COLLEGE ALUMNAE QUARTERLY v.7 no. 1:22-23 incl. port. Fall 1955.
18 The color problem in pure painting—its creative origin. IN Hans Hofmann. [Exhibition catalogue.] New York, Kootz Gallery, Nov.7-Dec. 3, 1955. p.[2-4].
 Reprinted in ARTS & ARCHITECTURE v.73 no.2: 14-15, 33-34 Feb.1956.—See also bibl. 32.
19 [Statement.] IN Hans Hofmann. [Exhibition announcement.] New York, Kootz Gallery, Jan. 7-26, 1957.
20 Nature and art. Controversy and misconceptions. IN Hans Hofmann. [Exhibition catalogue.] New York, Kootz Gallery, Jan.7-25, p. [3-4].
21 Statement. IT IS no.3:10 Winter-Spring 1959.
22 [Statement.] IN Contemporary American painting and sculpture. Urbana, University of Illinois, Mar.1-Apr.5, 1959. p.226.
23 Space and pictorial life. IT IS no.4:10 Autumn 1959.
24 [Statement.] IN Hans Hofmann. [Exhibition catalogue.] New York, Kootz Gallery, Jan.5-23, 1960. p.[2].
25 [Statement.] IN Contemporary American painting and sculpture. Urbana, University of Illinois, Feb.26-Apr.2, 1961. p.116.
26 [Letter to Ludwig Grote, Feb.10, 1962.] IN Hans Hofmann. [Exhibition catalogue.] Nuremberg, Fränkische Galerie am Marientor, 1962. p.17.
27 A speech delivered at the inauguration of the Hopkins Center, Dartmouth College, Hanover, New Hampshire, Nov.17, 1962. 7 p.
 Mimeographed typescript.
28 [Statement.] IN Contemporary American painting and sculpture. Urbana, University of Illinois, Mar.3-Apr.7, 1963. p.86.
29 The painter and his problems—a manual dedicated to painting. n.p. Mar. 21, 1963. 35 p.
 Mimeographed typescript.
30 Selected writings on art. n.p. n.d. 110 +7 p.
 Typescript available in Museum Library.
 Contents: Part 1. Earlier writings: First prospect of the Munich school. Spring 1915.—The search for the real in the visual arts.—Sculpture. — Painting and culture. — Excerpts from the teaching of Hans Hofmann. — Terms. — Part 2. Later writings: Nature and art. Controversy and misconceptions.—Identity of idea and form. — The object. —

Analysis of the creative act. — The mystification of the two- and three-dimensional in the visual arts.—The picture surface—push and pull. — The resurrection of the plastic arts. — The mystery of creative relations. — The color problem in pure painting — its creative origin. — Appendix: A new concept for mosaics of our time. — Cosmology as apprehended through the arts. — A speech delivered at the inauguration of the Hopkins Center, Dartmouth College, Hanover, New Hampshire, Nov. 17, 1962.

Most of the essays in part 1 were printed in "Search for the real" (bibl. 5). Some references in part 2 are noted in the citations above.

Monographs

31 **Greenberg, Clement.** Hofmann. Paris, Georges Fall, 1961. 62 p. incl. 21 ill. and 12 mount. col. pl. (The Pocket Museum.)
Includes bibliography. Modified versions in bibl. 41 and 69.

32 **Wight, Frederick S.** Hans Hofmann. Berkeley and Los Angeles, University of California Press, 1957. 66 p. incl. ill. (19 col.).
Published on the occasion of the retrospective exhibition organized 1957 by the Whitney Museum of American Art in association with the Art Galleries of the University of California. — Foreword by John I. H. Baur p.10. — The color problem in pure painting by Hans Hofmann p.51-56. — Hans Hofmann as muralist by Frederick S. Wight p. 58-59. — Selected bibliography p.64-66. — Reviewed by Alfred Werner in COLLEGE ART JOURNAL v.17 no.2:223 Winter 1958.

General Works

33 **American Abstract Artists, ed.** The world of abstract art. N. Y., Wittenborn, 1957. p.31(ill.), 109, 115, 116.

34 **Art Since 1945.** N. Y., Abrams [1958]. p.285, 286 IN chapter entitled "U.S.A." by Sam Hunter, col. pl. 146.

35 **Art — USA — Now.** Edited by Lee Nordness. Text by Allen S. Weller. N. Y., Viking, 1963. v.1, p.18-21 incl. ill. (1 col.), port.
Text on Hofmann by Kim Levin.

35a **Ashton, Dore.** The unknown shore: a view of contemporary art. Boston, Toronto, Little, Brown, 1961. p.194-196.

36 **Barker, Virgil.** From realism to reality in recent American painting. Lincoln, University of Nebraska, 1959. p.78-81 incl. 1 pl.

37 **Blesh, Rudi.** Modern art USA. Men, rebellion, conquest, 1900-1956. N. Y., Knopf, 1956. p. 166, 224, 240, 247, 262.

38 **Cheney, Sheldon.** Expressionism in art. 2 rev. ed. N. Y., Tudor, c1948. p. ix, 113, 156, 160, 176, 186, 212.
First ed. published 1934 by Liveright, N. Y.

39 **Eliot, Alexander.** Three hundred years of American painting. N. Y., Time Inc., 1957. p.274-275 incl. 1 col. ill., 277, 282.

40 **Goodrich, Lloyd.** American art of our century. [By] Lloyd Goodrich, John I. H. Baur. N. Y., Praeger, c1961. p.197-198, 202(col.pl.).

41 **Greenberg, Clement.** Art and culture. Critical essays. Boston, Beacon, c1961. p.189-196 and passim.

42 **Haftmann, Werner.** Painting in the twentieth century. N. Y., Praeger c1960. v.1 p.350, 351, 353, 393; v.2 p.448(ill.).
Completely revised version of the German edition which contains an entirely new chapter on contemporary American and British artists.

43 **Hess, Thomas B.** Abstract painting: background and American phase. N. Y., Viking Press, 1951. p.126, 131, 134-135 (2 ill.).

44 **Hunter, Sam.** Modern American painting and sculpture. N. Y., Dell (Laurel edition), c1959. p.133, 135-136, 148, 160, 207, col.pl. 31.

45 **Janis, Sidney.** Abstract & surrealist art in America. N. Y. Reynal & Hitchcock, c1944. p. 48, 50, 51, 79 plus 1 col. pl.
Statement by Hofmann, p.79.

46 **Kuh, Katharine.** The artist's voice. Talks with seventeen artists. N. Y. and Evanston, Harper & Row, 1962. p.118-129 incl. ill. 1 col. pl.

47 **Mendelowitz, Daniel M.** A history of American art. N. Y., Holt, Rinehart and Winston, c1960. p.599-600 incl. 1 ill.

48 **Modern Artists in America.** First series. Editorial associates: Robert Motherwell, Ad Reinhardt. N. Y., Wittenborn Schutz, Inc. [1951]. p.10-21, 106.
Hofmann one of the participants in "Artists' sessions at studio 35" (1950), p.10-21.

49 **Ponente, Nello.** Modern painting. Contemporary trends. Lausanne, Skira, c1960. p.147-149 and passim. 2 col.pl.

50 **Ritchie, Andrew Carnduff.** Abstract painting and sculpture in America. N. Y., Museum of Modern Art, c1951. p.102, 120 (ill.).
Published in connection with exhibition at the Museum of Modern Art, Jan.23 — Mar. 25, 1961. — Includes bibliography.

51 **Seitz, Wiliam C.** Abstract-expressionist painting in America. An interpretation based on the work and thought of six key figures. [Princeton, 1955.] 495 p.
Typescript. Dissertation.

52 **Seuphor, Michel.** Dictionary of abstract painting with a history of abstract painting. N. Y., Paris Book Center, Inc., 1957. p.189-190 incl. 1 ill.
Translation of French original "Dictionnaire de la peinture abstraite," Fernand Hazan, Paris, 1957.

53 **Szittya, Emile.** L'art allemand en France. Paris, Edition "La Zone," [193?]. p.25.
Translated from the German.

Articles

54 **Ashton, Dore.** Hans Hofmann. CIMAISE s.6 no. 3:38-45 incl. 5 ill Jan.-Mar. 1959.
Text in English and French.

55 **Bayl, Friedrich.** Hans Hofmann in Deutsch-

land. Art International v.6 no. 738-44 incl. ill. 1 col. pl. Sept. 1962.
In German. — Also in catalogue of Hofmann exhibition at Neue Galerie in Künstlerhaus, Munich, Sept. 1962.

56 [**Bird, Paul.**] Hofmann profile. Art Digest v.25 no.16:6-7 incl. port. May 15, 1951.

57 **Breeskin, Adelyn D.** Trois peintres américains. L'Oeil no.67/68:54, 56-57 incl. ill. (2 col.) July/Aug.1960.

58 **Burghart, Toni.** "Im Bilde schafft die Farbe das Licht." Baukunst und Werkform v.15 no.5:274, 276 incl. 1 ill. port. May 1962.
Partially an interview.

59 **Coates, Robert M.** The art galleries. A Hans Hofmann retrospective. New Yorker v.33 no.12: 104-106 May 11, 1957.

60 **De Kooning, Elaine.** Hans Hofmann paints a picture. Art News v.48 no.10:38-41, 58-59 incl. ill. port. Feb.1950.

61 **Elliott, Eugene Clinton.** Some recent conceptions of color theory. Journal of Aesthetics v.18 no.4: 502-503 June 1960.
The whole article p.494-503.

62 **Ellsworth, Paul.** Hans Hofmann; reply to questionnaire and comments on a recent exhibition. Arts & Architecture 66:22-28, 45-47 incl. ill. port. facsim. Nov. 1949.

63 **Estienne, Charles.** Hofmann ou La Lumière américaine. See bibl. 75.

64 **Feinstein, Sam.** "hh." in Hans Hofmann. [Exhibition catalogue.] New York, Kootz gallery, Apr.27-May 20, 1953. p.[2-3].

65 **Fitzsimmons, James.** Hans Hofmann. Everyday Art Quarterly no.28: 23-26 incl. ill. port. 1953.

66 **F[oster], J[ames] W., [Jr.].** Paintings by Hans Hofmann. in [Exhibition catalogue.] Santa Barbara Museum of Art, Feb. 1963.

67 **Greenberg, Clement.** "American type" painting. Partisan Review v.22 no.2:184-185 Spring 1955.
The whole article p.179-196.

68 **Greenberg, Clement.** Hans Hofmann. in A retrospective exhibition of the paintings of Hans Hofmann. [Catalogue.] Bennington, Vermont, Bennington College, [1955]. p. [2-3].

69 **Greenberg, Clement.** Hans Hofmann: grand old rebel. Art News v.57:26-29, 64 incl. ill. port. Jan. 1959.

70 **Greenberg, Clement.** Hofmann's early abstract paintings. in Hans Hofmann. [Exhibition catalogue.] New York, Kootz Gallery, Jan. 6-31, 1959. p.[4].

71 **Greenberg, Clement.** [Most important art teacher of our time.] The Nation Apr.21, 1945, p.469. Other citations may be found in his numerous reviews for The Nation.

72 **Grote, Ludwig** [Introduction to] Hans Hofmann. [Exhibition catalogue.] Nuremberg, Fränkische Galerie am Marientor, 1962. p.3-4.

73 **H[ess], T[homas] B.** Art News visits the art schools: 3 in Provincetown. Art News v.45 no.4:12-13 incl. 1 ill. June 1946.

74 **Hofmann, Hans.** Current Biography v.19:195-197 incl. port. 1958.

75 Hans Hofmann. Derriere le Miroir no. 16: [1-6] incl. 1 ill. 1 port. Jan. 1949.
Contents: A salvo for Hans Hofmann [by] Weldon Kees. — Hans Hofmann par Peter Neagoe. — Hofmann ou La lumière américaine par Charles Estienne. — An appreciation by Tennessee Williams. — Oeuvres exposées.

76 **Kaprow, Allen.** Hans Hofmann.
Typescript (4 p.) of article written in connection with exhibition at Rutgers University, New Brunswick, New Jersey, April-May 1956.

77 **Kees, Weldon.** A salvo for Hans Hofmann. See bibl. 75.

78 **Kees, Weldon.** Weber and Hofmann. Partisan Review v.16 no. 5:541-542 May 1949.

79 A master teacher. Hans Hofmann influenced three decades of U.S. art. Life v.42 no.14:70-72, 74, 76 incl. ill.(pt. col.) port. Apr.8, 1957.

80 **Matter, Mercedes.** Hans Hofmann. Arts & Architecture 63:26-28, 48 incl. 4 ill. May 1946.

81 **Negoe, Peter.** Hans Hofmann. See bibl. 75.

82 **Plaskett, Joe.** Some new Canadian painters and their debt to Hans Hofmann. Canadian Art v.10 no.2:59-63, 79 incl. ill. Winter 1953.

83 **Pollet, Elizabeth.** Hans Hofmann. Arts v.31 no.8:30-33 incl. ill.(2 col.) May 1957.

84 **Rosenberg, Harold.** Hans Hofmann: nature into action. Art News v.56 no.3:34-36, 55-56 incl. ill.(1 col.) port. May 1957.

85 **Rosenberg, Harold.** Hans Hofmann's 'life' class. Portfolio & Art News Annual no.6:16-31, 110-115 incl. ill. (7 col.), port., Autumn 1962.

86 **Sawyer, Kenneth B.** Largely Hans Hofmann. Baltimore Museum of Art News v.18 no.3:9-12 incl. 1 ill.

87 **Seckler, Dorothy.** Can painting be taught? 2. Hofmann's answer. Art News v.50. no.1:40, 63-64 incl. ill. port. Mar. 1951.

88 **Willard, Charlotte.** Living in a painting. Look v.17 no.15:52-55 Jul.28, 1953.

89 **Williams, Tennessee.** An appreciation. See bibl. 75.

90 **Wolf, Ben.** The Digest interviews Hans Hofmann. Art Digest v.19 no.13:52 Apr.1, 1945.

Addenda

91 [Hofmann Students Dossier]. 1963.
Typescripts. — Replies to questionnaire on Hofmann as a teacher by his students. Documents on deposit in The Museum of Modern Art Library.

catalogue

Exhibition dates in New York: Sept. 11-Nov. 28, 1963. A few works, indicated by (NY) and (NY;USA), are exhibited in New York only, or in the United States only. They will be replaced by comparable works. In dimensions, height precedes width. Wherever discrepancies occur between captions and this catalogue, the information given here is more recent. Works illustrated in color are marked with an asterisk.

1 **Spring.** 1940. Oil on wood, 11⅜ x 14⅜". Collection Peter A. Rübel, Greenwich, Conn. Ill. p. 24.

2 **Fantasia.** 1943. Oil on plywood, 51½ x 36⅝". Signed and dated lower right. Owned by the artist. (NY). Ill. p. 25.

3 **Bacchanale.** 1946. Oil on cardboard, 63½ x 47⅞". Signed and dated lower right. Owned by the artist. Ill. p. 38.

4 **Ecstasy.** 1947. Oil on canvas, 68 x 60". Owned by the artist. Ill. p. 22.

5 **Liebesbaum.** 1954. Oil on plywood, 60⅞" x 30". Signed and dated lower right. Owned by the artist. Ill. p. 40.

6 **Yellow Burst.** 1956. Oil on canvas, 52¼ x 60¼". Signed and dated lower right. Collection Mr. and Mrs. Samuel M. Kootz, New York. Ill. p. 43.

7 **The Garden.** 1956. Oil on plywood, 59⅞ x 46¼". Signed lower right. Owned by the artist. Ill. p. 19.

8 **The Prey.** 1956. Oil on composition board, 60 x 48⅛". Signed and dated lower right. Owned by the artist. Ill. p. 37.

9 **Golden Splendor.** 1957. Oil on canvas, 84 x 50". Signed and dated lower right. Collection Mr. and Mrs. Joseph H. Hazen, New York. (NY;USA). Ill. p. 12.

10 **Kaleidos.** 1958. Oil on plywood, 72⅛ x 31⅞". Signed and dated lower right. Owned by the artist. Ill. p. 26.

11 **Rhapsody.** 1958. Oil on plywood, 71⅞ x 32". Signed and dated lower right. Owned by the artist. Ill. p. 17.

*12 **Towering Clouds.** 1958. Oil on canvas, 50¼ x 84". Signed and dated lower right. Collection Mr. and Mrs. Samuel M. Kootz, New York. Ill. pl. 1.

13 **Moloch.** 1958. Oil, lacquer and paper collage on plywood, 60⅞ x 30". Owned by the artist. Ill. p. 63.

14 **Cathedral.** 1959. Oil on canvas, 74⅛ x 48⅛". Signed and dated lower right. Owned by the artist. Ill. p. 31.

15 **Festive Pink.** 1959. Oil on canvas, 60 x 72". Signed and dated lower right. Collection Miss Vera Vio, Rome. Ill. p. 13.

Moloch. 1958.
Oil, lacquer, and paper collage on plywood, 60⅞ x 30".
Owned by the artist

*16 **Conjurer.** 1959. Oil on composition board, 59½ x 45". Signed and dated lower right. Municipal Gallery, Lenbachhaus, Munich (Bavarian State Painting Collection). Ill. pl. 2.

17 **Black Goddess.** 1960. Oil on canvas, 48⅛ x 36⅛". Signed and dated lower right. Owned by the artist. Ill. p. 32.

18 **The Gate.** 1960. Oil on canvas, 74⅝ x 48¼". Signed and dated lower right. The Solomon R. Guggenheim Museum, New York. (NY). Ill. p. 33.

19 **Image of Fear.** 1960. Oil on canvas, 84 x 60". Signed and dated lower right. Samuel M. Kootz Gallery, New York. Ill. p. 23.

*20 **Pre-Dawn.** 1960. Oil on canvas, 72 x 60". Signed and dated lower right. Collection Prentis C. Hale, San Francisco. (NY;USA). Ill. pl. 3.

*21 **Lava.** 1960. Oil on canvas, 72 x 60". Signed and dated lower right. Collection Mr. and Mrs. Paul Tishman, New York, Ill. pl. 4, details pp. 44, 45, and cover.

22 **In the Wake of the Hurricane.** 1960. Oil on canvas, 72¼ x 60". Signed and dated lower right. Owned by the artist. Ill. p. 42.

23 **The Phantom.** 1961, Oil on canvas, 84 x 72". Signed and dated lower right. Private collection, New York. (NY). Ill. p. 35.

24 **Combinable Wall.** 1961. Oil on canvas. Left: Part II 84¼ x 52¼"; right: Part I 84⅜ x 60¼", signed and dated lower right. Owned by the artist. Ill. p. 28/29.

25 **Moonshine Sonata.** 1961. Oil on canvas. 78⅛ x 84⅛". Signed and dated lower right. Samuel M. Kootz Gallery, New York. Ill. p. 52.

26 **The Golden Wall.** 1961. Oil on canvas, 60 x 72¼". The Art Institute of Chicago, Mr. and Mrs. Frank G. Logan Purchase Prize Fund. (NY). Ill. p. 10.

27 **Agrigento.** 1961. Oil on canvas, 84 x 71¾". Signed and dated lower right. Owned by the artist. Ill. p. 20.

*28 **Summer Night's Bliss.** 1961. Oil on canvas, 84¼ x 77⅞". Signed and dated lower right. The Baltimore Museum of Art. Ill. pl. 5.

29 **". . . and thunder clouds pass"** (Nikolaus Lenau). 1961. Oil on canvas, 84⅛ x 60¼". Signed and dated lower right. Owned by the artist. Ill. p. 16.

30 **Image of Cape Cod: The Pond Country, Wellfleet.** 1961. Oil on canvas, 60⅛ x 52". Signed and dated lower right. Samuel M. Kootz Gallery, New York. Ill. p. 6.

31 **Wild Vine.** 1961. Oil on canvas, 72 x 60". Signed and dated lower right. Collection Mr. and Mrs. David E. Bright, Beverly Hills, Calif. (NY). Ill. p. 41.

32 **Mecca.** 1961. Oil on canvas, 84 x 60". Signed and dated lower right. Collection Mrs. Albert H. Newman, Chicago. (NY). Ill. p. 51.

*33 **Delirious Pink.** 1961. Oil on canvas, 60 x 48⅛". Signed and dated lower right. Owned by the artist. Ill. pl. 6.

34 **Tormented Bull.** 1961. Oil on canvas, 60 x 83⅞". Signed and dated bottom right of center. Owned by the artist. (NY). Ill. p. 9.

*35 **Lumen Naturale.** 1962. Oil on canvas, 84 x 78". Signed and dated lower right. Samuel M. Kootz Gallery, New York. Ill. pl. 7.

*36 **The Whisper of the South Wind.** 1962. Oil on canvas, 60 x 72". Signed and dated lower right. Owned by the artist. Ill. pl. 8.

37 **Memoria in Aeterne** — Dedicated to Arthur Carles, Arshile Gorky, Jackson Pollock, Bradley Walker Tomlin, Franz Kline. 1962. Oil on canvas, 84 x 72⅛". Signed and dated lower right. Samuel M. Kootz Gallery, New York. Ill. p. 55.

38 **Magnum Opus.** 1962. Oil on canvas, 84 x 78". Signed and dated lower right. Samuel M. Kootz Gallery, New York.

39 **Ignotum per Ignotius.** 1963. Oil on canvas, 84¼ x 60". Owned by the artist. Ill. p. 34.

40 **Blue Rhapsody.** 1963. Oil on canvas, 84 x 78". Signed and dated lower right. Owned by the artist. Ill. p. 36.

Museum of Modern Art Publications in Reprint

Max Ernst. 1961. William S. Lieberman

Fantastic Art, Dada, Surrealism. 1947. Barr; Hugnet

Feininger-Hartley. 1944. Schardt, Barr, and Wheeler

The Film Index: A Bibliography (Vol. 1, The Film as Art). 1941.

**Five American Sculptors: Alexander Calder; The Sculpture of John B.
 Flannagan; Gaston Lachaise; The Sculpture of Elie Nadelman; The
 Sculpture of Jacques Lipchitz.** 1935-1954. Sweeney; Miller, Zigrosser;
 Kirstein; Hope

**Five European Sculptors: Naum Gabo—Antoine Pevsner; Wilhelm Lehmbruck—
 Aristide Maillol; Henry Moore.** 1930-1948. Read, Olson, Chanin; Abbott;
 Sweeney

**Four American Painters: George Caleb Bingham; Winslow Homer, Albert P.
 Ryder, Thomas Eakins.** 1930-1935. Rogers, Musick, Pope; Mather, Burroughs,
 Goodrich

German Art of the Twentieth Century. 1957. Haftmann, Hentzen and Lieberman;
 Ritchie

Vincent van Gogh: A Monograph; A Bibliography. 1935, 1942. Barr; Brooks

Arshile Gorky. 1962. William C. Seitz

Hans Hofmann. 1963. William C. Seitz

Indian Art of the United States. 1941. Douglas and d'Harnoncourt

**Introductions to Modern Design: What is Modern Design?; What is
 Modern Interior Design?** 1950-1953. Edgar Kaufmann, Jr.

Paul Klee: Three Exhibitions: 1930; 1941; 1949. 1945-1949. Barr;
 J. Feininger, L. Feininger, Sweeney, Miller; Soby

Latin American Architecture Since 1945. 1955. Henry-Russell Hitchcock

Lautrec-Redon. 1931. Jere Abbott

Machine Art. 1934. Philip Johnson

John Marin. 1936. McBride, Hartley and Benson

Masters of Popular Painting. 1938. Cahill, Gauthier, Miller, Cassou, et al.

Matisse: His Art and His Public. 1951. Alfred H. Barr, Jr.

Joan Miró. 1941. James Johnson Sweeney

Modern Architecture in England. 1937. Hitchcock and Bauer

Modern Architecture: International Exhibition. 1932. Hitchcock, Johnson,
 Mumford; Barr

Modern German Painting and Sculpture. 1931. Alfred H. Barr, Jr.

Modigliani: Paintings, Drawings, Sculpture. 1951. James Thrall Soby

Claude Monet: Seasons and Moments. 1960. William C. Seitz

Edvard Munch; A Selection of His Prints From American Collections. 1957.
 William S. Lieberman

The New American Painting; As Shown in Eight European Countries, 1958-1959.
 1959. Alfred H. Barr, Jr.

New Horizons in American Art. 1936. Holger Cahill

New Images of Man. 1959. Selz; Tillich

Organic Design in Home Furnishings. 1941. Eliot F. Noyes

Picasso: Fifty Years of His Art. 1946. Alfred H. Barr, Jr.

Prehistoric Rock Pictures in Europe and Africa. 1937. Frobenius and Fox

Diego Rivera. 1931. Frances Flynn Paine

Romantic Painting in America. 1943. Soby and Miller

Medardo Rosso. 1963. Margaret Scolari Barr

Mark Rothko. 1961. Peter Selz

Georges Roualt: Paintings and Prints. 1947. James Thrall Soby

Henri Rousseau. 1946. Daniel Catton Rich

Sculpture of the Twentieth Century. 1952. Andrew Carnduff Ritchie

Soutine. 1950. Monroe Wheeler

Yves Tanguy. 1955. James Thrall Soby

Tchelitchew: Paintings, Drawings. 1942. James Thrall Soby

Textiles and Ornaments of India. 1956. Jayakar and Irwin; Wheeler

Three American Modernist Painters: Max Weber; Maurice Sterne; Stuart Davis. 1930-1945. Barr; Kallen; Sweeney

Three American Romantic Painters: Charles Burchfield: Early Watercolors; Florine Stettheimer; Franklin C. Watkins. 1930-1950. Barr; McBride; Ritchie

Three Painters of America: Charles Demuth; Charles Sheeler; Edward Hopper. 1933-1950. Ritchie; Williams; Barr and Burchfield

Twentieth-Century Italian Art. 1949. Soby and Barr

Twenty Centuries of Mexican Art. 1940

Edouard Vuillard. 1954. Andrew Carnduff Ritchie

The Bulletin of the Museum of Modern Art, 1933-1963. (7 vols.)

This reprinted edition was produced by the offset printing process. The text and plates were photographed separately from the original volume, and the plates rescreened. The paper and binding were selected to ensure the long life of this library grade edition.